W9-BXZ-402

DATE D

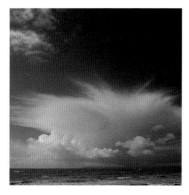

photographing
weather

Storm Dunlop

photographing
weather

Storm Dunlop

photographers'
pip
institute press

First published 2007 by
Photographers' Institute Press / PIP
an imprint of The Guild of Master Craftsman Publications Ltd,
166 High Street, Lewes, East Sussex BN7 1XU

ISBN 978-1-86108-449-1

British Cataloguing in Publication Data. A catalogue record of this book is available from the British Library.

Production Manager: Jim Bulley
Managing Editor: Gerrie Purcell
Photography Books Project Editor: James Beattie
Managing Art Editor: Gilda Pacitti
Designer: James Hollywell

Typefaces: Frutiger and Lubalin Graph
Colour reproduction by Altaimage
Printed and bound by Hing Yip

Contents

Introduction

Photographing the weather and its various associated phenomena is a fascinating pursuit. Everyone with a camera has tried to capture striking sunsets or beautiful rainbows, but there are many other subjects also worth recording. Not only the ever-changing clouds, but also the many optical phenomena and colour effects that can go unnoticed; often because people don't realize what they are seeing, or even know that such effects exist. Even the basic cloud types are a mystery to most people. All good photographers need to develop an eye for their subject, and weather photography is no exception. It really helps to have an idea of the different types of clouds; how they form and develop; how certain other effects occur; and where and when they may be seen. So this book includes advice on some of the basic principles of the weather, as well as practical advice on how best to photograph it.

▼ Wherever we are in the world, weather provides a great many photographic opportunities.

If you have a camera already, there is no reason why you should not continue to use it. Don't assume you need to have the latest, most expensive equipment; how a camera is used is more important than its brand or model, although, that said, the quality of the lenses and film or sensor is also important.

If you are already familiar with a particular camera, you are more likely to carry it with you and be ready to take photographs when the occasion arises. Naturally, every camera or camera system has its limitations, so we shall discuss specific equipment a little later. Certainly, photographing the weather can present some challenges, but you should consider changing your equipment only when you begin to find that it does not allow you to capture the specific images that you had in mind, or you find that it does not give you the image quality that you would like.

Film or digital

Although digital cameras are now very popular, there is no pressing need for you to go digital if you have a good film camera. Most of the photographs in this book are from an extensive collection of transparencies, built up over the years, a few were shot on negative film, while more recent images were taken with a digital camera. I used transparencies because I use images in lectures and for articles in journals or books, for both of which slides are better than prints.

The growth of digital photography has been, in part, because of the wealth of options that it offers. The greatest control comes when using a photo-editing program to correct errors and make adjustments, and then producing prints on a photo-quality printer. But a computer is not essential. Even simple digital cameras or their memory cards may be connected directly to many printers, some of which have screens so that one may preview the final image.

Seeing the sky

Before you photograph objects in the sky, you must be able to see them. Many phenomena are visible only close to the Sun, and frequently go unnoticed simply because they are overwhelmed by the glare. Coronae (page 97), haloes (page 102), and iridescence (page 98) are just three effects rarely seen by casual observers. There are various clues that become apparent once you are familiar with the types of cloud and how they cause specific phenomena, and these are mentioned later.

Although you can simply hide the Sun behind a hand or building, other methods of reducing glare are useful. Photochromic spectacles will help, but mirror-type sunglasses are particularly effective. If available, two plastic polarizer sheets are ideal, because they may be rotated relative to one another, changing from almost complete

transmission to almost complete opacity. Reflections from a pool of water, from windows or other sheets of glass will also reduce the intensity of light from the Sun – the tinted glass used in many modern buildings is also often effective.

It also helps to be able to determine angles, especially as certain cloud types (stratocumulus, altocumulus, and cirrocumulus) are specified in terms of the angular size of individual elements. One method is to hold a ruler, marked in centimetres, at arm's length. One centimetre then subtends about one degree. A simpler method is to use your hand at arm's length: the width of one finger is about one degree; that over the knuckles of a closed fist is roughly 10 degrees; and spanning the fingers gives about 22 degrees from thumb to little finger. These are useful tricks for estimating a subject's extent or altitude.

Chapter 1
Equipment

Photographing weather phenomena is not particularly difficult, but there are a few considerations to bear in mind when choosing equipment. Obviously any type of camera may be used, but it is not easy to decide which is 'best'. Ideally, one would have more than one camera, and choose the most appropriate for the occasion. Most of the images in this book were obtained with a single-lens reflex system over the years; but others, including some of the images of rare phenomena, were taken with an older rangefinder camera with interchangeable lenses, and some with an old-fashioned, but good-quality, compact camera. Later images have been obtained with a high-spec digital SLR.

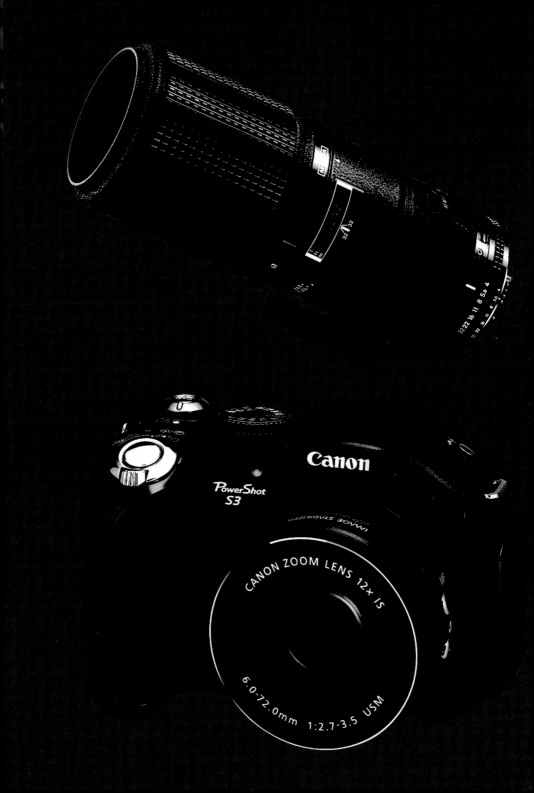

Cameras

To deal with a range of conditions, a film or digital SLR (single-lens reflex) system with interchangeable lenses, filters and a tripod offers the best chance of success. It is possible to carry such a collection on a day devoted to photography, but it is often impractical to do so. Yet weather conditions are often changeable, and some phenomena are so rare that a camera may be required at any time. Medium-format and large-format cameras can be used for weather photography, but most are too cumbersome and expensive to be suitable for the purpose. There are, however, many suitable cameras, and these can be divided into three broad groups: compact cameras; mid-range cameras; and SLR systems.

Compact cameras

As the name implies, compact cameras are small and lightweight. Most are simple and relatively inexpensive, with a limited range of functions. The low size and weight mean that compacts are useful, because they may be carried at all times. However, the small size of compacts means that the quality of the lens and digital sensor is often compromised. Many modern compacts have a zoom facility, and if it is a digital camera, this should be a true zoom lens, rather than a digital zoom – which sacrifices image quality for magnification. Similarly, the sensors in compact digital cameras are often much smaller than those in mid-range cameras and SLRs and tend to suffer from more noise (see page 14), which degrades the image.

Two specific disadvantages of most compacts are their lack of a lens hood, which is vital as it is often necessary to shoot close to the Sun, and a proper filter mount. A few compacts allow the use of a push-fit lens hood or filter. It is possible to improvise, and hold a filter in front of the lens, but this is not ideal, and polarizing filters, in particular, are almost essential.

A more general limitation is that only more sophisticated (and expensive) compacts allow much control over exposure, focus and other variables.

▼ Compact cameras may not offer the same quality as an SLR, but they can be carried conveniently.

Mid-range cameras

There have always been cameras that fall between compact cameras and the more versatile SLR systems, but this type of camera has become more popular since the advent of digital photography. Sometimes known as 'prosumer' cameras, most offer a zoom lens and full control over the various settings; some have a range of controls that rivals that of many digital-SLR (DSLR) systems. Useful accessories, such as wideangle and telephoto converters and proper lens hoods and filter attachments, are also available. These cameras are relatively small and light, and offer a solution if you do not want to carry too much gear or if you are unable to justify the expense of an SLR system. That said, the competition in the digital-SLR market has caused companies to produce DSLRs that are almost as compact and cheap as mid-range cameras.

SLR systems

The greatest flexibility is offered by cameras with interchangeable lenses and a wide range of functions. Some rangefinder cameras have these features, but single-lens reflex systems dominate both the 35mm film and digital markets for amateur enthusiasts and professionals alike. The latest digital SLRs are remarkably sophisticated, although they are, of course, more expensive than the simpler types. It is also true that many of the available functions are rarely required for weather photography. To obtain the best results it is also important to have access to a suitable computer, image-processing software, and a good-quality printer. Overall, they probably require users to have a greater understanding of the photographic process and of the various – and very numerous – factors that affect the quality of the final image.

▼ Mid-range cameras fall between SLRs and compact cameras. They offer a compromise between convenience, quality and flexibility.

▼ Digital SLRs have fallen in price, and now consumer models offer high quality at relatively low prices.

Desirable features

When anything but the most basic compact camera is being considered, there are a number of features that are extremely valuable and of great assistance when photographing weather phenomena. These will be discussed in detail where relevant, but they may usefully be summarized here. It is assumed that the camera has automatic exposure metering.

Essential or desirable features:
- **autofocus lock**
- **manual focusing mode**
- **exposure lock**
- **spot metering**
- **depth-of-field preview**
- **bulb ('B') setting for long low-light and lightning exposures**

The more sophisticated digital cameras frequently offer many ways of manipulating the image within the camera. Some of these, such as contrast control, are easily (and generally better) applied at a later stage in the computer, but may be of use if images are required for immediate use. Certain desirable features will, however, be discussed specifically: white balance adjustment, noise filters and noise reduction, lack of fringing at high-contrast boundaries, pixel mapping, dust-elimination systems, shading compensation, and exposure and other details recorded as EXIF data.

White balance

All luminous sources emit light over a range of wavelengths, but the peak values differ greatly depending on the source. Some may give an intense blue-white light, for example, whereas others may give a deep red light. The different values are expressed in terms of a source's 'colour temperature' (see box opposite). Photographs taken under light from different sources will record different tints. White balance adjustment allows for the correction of any colour cast that might result.

The digital adjustment of white balance (WB) is normally used when taking photographs under artificial light or when skin tones are important. (With film cameras a similar adjustment may be made with filters.) It can also be useful for weather images, particularly near sunrise and sunset, when photographs taken with a normal colour-temperature setting of 5,000–6,000K may display lurid 'unnatural-looking' tints. A setting closer to the value normally prevailing at such times (see page 99) should provide a more pleasing image. Sometimes, too, the automatic WB system used on digital cameras may give an overall blue cast, which needs to be corrected. It is not always easy to assess the extent of a subtle colour cast on a digital camera's screen, but the adjustment is usually simple to carry out on computer. Note that if files are recorded in RAW format (see page 132), any white-balance or other corrections can be made easily during conversion.

▼ A comparison of two versions of an aerial photograph showing cumulus congestus rising above a deep haze layer that had built up during the day, and which occasionally allowed faint glimpses of the ground. The horizon is not level, because the aircraft was banking at the time. The blue cast is readily apparent in the left-hand image, taken directly from the original transparency. On the right, the image has been modified using the Adobe Photoshop Elements automatic 'Smart Fix' option.

weather watching
colour temperature

Colour temperature is the temperature at which a perfect emitter would produce radiation similar to that of the source under consideration. This is expressed on the Kelvin scale, which has its zero point at absolute zero (0K = −283.16°C). For example, the colour temperature of direct sunlight is 5,400K. Counterintuitively, the higher the colour temperature, the cooler the light appears – the closer to the blue end of the visible spectrum; conversely, the lower the colour temperature, the warmer the light – the closer to the red end of the spectrum.

Noise

One significant problem with weather images is that they often contain large areas of even tone (the sky, clouds, snow and so on), where any noise or dirt is extremely noticeable. With film cameras this means taking every precaution against dust and scratches on the film, and frequent precautionary cleaning. With digital cameras, the noise level of the sensor is significant, and may be intrusive in compact cameras, which tend to have smaller sensors than mid-range cameras (and much smaller than those in digital SLRs). The latest sensors are generally very satisfactory in this respect, unlike some of the earlier ones, which tended to show some noise, even at normal daylight illumination levels. All sensors tend to produce more noise when the ISO-equivalent rating (see page 42) is increased. This may sometimes become apparent in night-time shots of subjects such as noctilucent clouds (see page 77) and aurorae (see pages 88–9).

There are two general methods by which noise may be reduced: noise filtering and noise reduction. In the first, which is carried out in the camera, background noise in evenly tinted areas is detected and suppressed by comparing individual pixels with surrounding ones. This is often the best method when the camera is used at relatively low ISO-equivalent ratings, normally 100–400.

The second method (noise reduction) is completely different:

◀ ▲ The main image – actually showing the Moon rising in the east above the Earth's shadow, with some thin cirrus cloud – has large areas of even tint, which are particularly prone to noise. The enlargement of the area near the Moon reveals that the camera's sensor is remarkably free from any form of noise. (No noise filter, noise reduction, or other processing has been applied to this image. Neither has pixel mapping of faulty pixels been carried out.)

following the exposure, a second exposure is made with the shutter closed. This detects any spurious pixels that show a charge, and subtracts their effects from the actual photograph. This method is especially effective for low-light and night exposures that require the camera to be mounted on a tripod, and when the camera is set to ISO 800 or higher. It may also be applied at any time when there are particularly large areas of even tone.

The first of these methods may, of course, be carried out by special routines applied in the computer at a later stage. Similar routines are used by some scanning programs to minimize the effects of dust and scratches on prints, transparencies, and negatives.

kit
pixel mapping

Problems similar to noise may also occur if the sensor has, or develops, faulty pixels. Many individual models of camera offer a method of mapping and excluding these, determining the value to be assigned to each individual faulty pixel by interpolation from surrounding image pixels. Given the large areas of even tone that often occur in weather images, faulty pixels may be very evident, so an option for mapping and compensation is highly desirable.

Fringing

One problem that did not occur to such a great extent with film cameras, but may be quite visible with some digital cameras, is that of colour fringes that appear at high-contrast boundaries. Such boundaries often occur where objects (such as the leaves and branches of trees) are silhouetted against the bright sky. Early digital cameras were particularly prone to this problem, and it may also arise when lenses that were not manufactured with digital sensors in mind are employed. Each pixel is covered by an individual microscopic lens, and ideally the rays of light

incident upon each lens should be parallel or at only a shallow angle to the lens axis. A portion of the light striking the edge of each microlens may be reflected away, and affect a neighbouring pixel. This tends to reduce resolution and contrast. With very high-contrast boundaries, however, the effect may be strong enough to produce a coloured fringe parallel to the actual boundary. The most recent digital cameras, and especially DSLRs with interchangeable lenses computed specifically for use with digital sensors, are essentially free from this fault.

Dust-reduction systems

Keeping a camera's sensor free from dust – especially in DSLRs, with which interchangeable lenses offer more opportunities for dust to enter the camera – is a great challenge. Conventional cleaning techniques, especially the use of cans of compressed air, may make the situation worse, because they may leave a sticky deposit on the sensor. The supersonic dust filter introduced by Olympus on its E-series digital SLRs is remarkably effective. The thin low-pass filter in front of the sensor is oscillated at a high frequency, dislodging any dust particles, which are then trapped in a special chamber within the camera. I have examined a number of images with large evenly tinted areas at the pixel level and have failed to detect a single dust particle. (This also shows that the sensor of my DSLR is currently completely free from faulty pixels.)

Canon has introduced a slightly different system on the EOS 400D, with an anti-static coating on the low-pass filter, combined with vibration of the filter to shake off dust. Sony and Pentax have also introduced similar systems that seek to dislodge the dust.

While you should endeavour to keep the sensor free of dust, by being careful where and how you change lenses, the sensors in cameras without these features may need to be cleaned from time to time. The two most common methods are with a hand blower (without a brush), or by using a purpose-designed cleaning system using special swabs (specifically designed for individual models of camera) and a cleaning fluid. Either method requires that the reflex mirror should be retracted, and the shutter opened. This is usually an option on the menu system, but otherwise the bulb ('B') setting may be used. Note that it is essential to ensure either that the battery is fully charged or that the camera is connected to a mains adaptor. If the power were to fail during the cleaning operation, the shutter and mirror would return to their normal positions, potentially forcing the blower or swab against the sensor and causing severe damage.

◄ Olympus was the first manufacturer to pioneer a dust-reduction system in its E-system DSLRs with its Supersonic Wave system, but other manufacturers have since added various measures to reduce dust and the effects of dust in their cameras.

Shading compensation

All lenses, and particularly ultra-wideangle lenses, are prone to vignetting, which means some decline in illumination at the edges of the field. This vignetting may be inherent, because the rays of light fall on the film or sensor at an angle and have less effect, or it may result from using a lens at a very wide aperture. In the latter case, the effect may be minimized by using a smaller aperture, and increasing the exposure time. In film cameras, inherent vignetting was sometimes tackled by using a neutral-density radial filter, with the density decreasing outwards from the centre, to give progressively greater exposure towards the edges of the frame.

With the advent of digital imaging, it has become possible to compensate for this effect in the camera. In the Olympus E-1, for example, it is known as 'shading compensation'. It does have one considerable disadvantage, in that the computation required greatly extends the time (by a factor of five or six) before the image is written to the memory card. Generally, this facility will not be required, but it is of particular use in low-light situations, when the vignetting may become readily apparent in areas that would otherwise be of even (or evenly graduated) tint. Alternatively, you could shoot the frame as a RAW file, then apply compensation, if your conversion software allows it.

EXIF data

The rigorous manual recording of all the relevant details for each exposure is something that only the most disciplined photographers manage to carry out. The Exchangeable Image File Format (EXIF) standard has solved this problem completely. This may seem a relatively minor point, but if rare phenomena (such as unusual halo arcs) are photographed, they may well be of considerable scientific interest. Not only are the date and time important, but it is essential to know the exact focal length that was used, so that the angular dimensions and exact position of a phenomenon in the sky may be calculated. With zoom lenses, recording the exact focal length used for any particular shot can become particularly onerous and prone to error. EXIF data provides an easy solution to this. Because the descriptions of each individual field in the EXIF data are rather technical, many photographic manipulation programs display the information in a more readily understood form. As well as this, most allow the addition of information (which is known as metadata) such as captions, keywords and so on, in the standard IPTC (International Press Telecommunications Council) format.

Accessories

Many camera systems offer masses of accessories. As explained earlier you don't have to invest heavily in the latest equipment, but certain acccessories are of particular use in photographing weather subjects, in particular polarizing filters, UV and skylight filters, plain or graduated neutral-density filters, a good-quality tripod with a pan-and-tilt head, a remote shutter release or cable release, a viewfinder grid, a spirit level, and a shade or hood for the LCD screen on digital cameras.

Tripods

Good-quality, stable tripods tend to be fairly heavy and cumbersome, although weight savings may be made if one invests in one of the modern, expensive, carbon-fibre types. Tripods are essential if long-focus telephoto lenses are used, and when photographing in low-light conditions (such as around dawn and dusk), as well as for night-time shots of subjects such as noctilucent clouds (page 77) and aurorae (pages 88–9). They are strongly recommended for all panoramic shots.

Most tripods are supplied with a ball-and-socket head, where the camera platform is supported on a ball, which is free to move in a socket that is attached to the tripod itself. There is a screw- or trigger-operated clamp to lock the ball in any position, and normally a cut-out at one side to hold the camera at 90° (in a portrait rather than landscape orientation). A better solution is offered by a pan-and-tilt head. The most common form of this enables the camera's orientation to be adjusted by rotation around two axes: one vertical, to give the panning motion in a horizontal plane; and the other horizontal, to give the tilt in a vertical direction. These heads are often more robust than the ball-and-socket type. One drawback is that it is a little inconvenient to change the camera's orientation from landscape to portrait format. Superior heads have a third rotational axis that allows the camera platform to be tilted from one orientation to the other (and intermediate orientations as well).

It is very important that the head can be firmly locked in any given position and does not gradually move under the weight of the camera and lens. A quick-release mechanism is also extremely useful, not least because it also allows the camera to be mounted on the tripod very quickly.

For general daytime use, a ball-and-socket head will usually suffice, but if panoramic images are of particular interest, ensure that the tripod has an adequate pan-and-tilt head and, specifically, that the head will hold the

camera in a truly vertical position to give portrait-format images. I favour Benbo tripods, because of their versatility, but unfortunately these are not currently supplied with pan-and-tilt heads. I therefore use mine with a good-quality Manfrotto three-axis head, which has graduated scales on two axes (and a quick-release mechanism). A spirit-level is used to ensure that the tripod and head have been correctly set, and the actual exposure should be made either with a cable release or a remote shutter release unit.

One of the small, table-top tripods, of either the rigid or flexible type, is useful on occasions, as is a bean bag, which may be placed on a wall, rock, or tree stump, and used to steady the camera. Although monopods are useful, a length of stout cord or light chain, attached to a threaded fitting that will go into the tripod socket on the camera, will serve nearly as well. If you stand on one end of the cord or chain, and bear upwards on the camera, it will be steadied very effectively. If all else fails, then you can borrow a trick from amateur astronomers who need to steady hand-held binoculars, and rest the camera on an upturned, long-handled brush or broom.

The anti-shake systems that have been introduced on some digital cameras (such as the Sony Alpha 100) and those included on some lenses may be useful, but they are no real substitute for a sturdy tripod. Apart from the additional cost, there are some technical disadvantages in both of the systems commonly employed at present: moving a lens element, and moving the sensor. In theory, the former leads to a slight degradation of the image (because the moving element is slightly off-axis), and every individual lens has to incorporate the system. With the latter, there are lesser optical effects, but more complications introduced by the additional processing required.

kit
spirit levels

A spirit level proves of greatest value when obtaining images that are to be combined to form a panorama. It needs, of course, to be used with a tripod or some other form of support. The type that slips into a camera's hotshoe is usually perfectly adequate, but if panoramic images are of particular interest, it may pay to invest in a pan-and-tilt head that incorporates one into its design. If only landscape-format images are likely to be used, a simple accessory head that incorporates a spirit level, and allows panning but not tilting, may suffice.

Viewfinder grid

A viewfinder with a rectangular grid is extremely useful for ensuring that horizons, particularly sea horizons, for example, are truly horizontal. It is also of great assistance when taking a series of images that are to be combined into a panorama. Some mid-range cameras and digital SLRs offer on-demand gridlines. A few of the more expensive cameras offer interchangeable focusing screens. Special adhesive screens with a grid of lines are available for digital cameras that use the rear LCD as a viewfinder. (The adhesive is of a special type that does not leave any residue when removed.) Incidentally, if it is not already protected with a plastic cover, it is also well worth using a special adhesive sheet to protect an LCD screen from scratches.

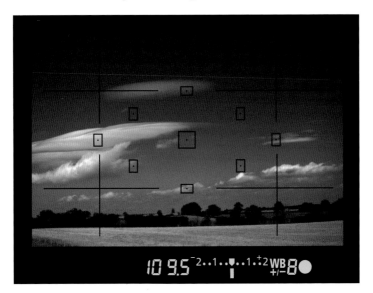

Shade or hood for LCD screen

Given that many weather photographs are (we hope) going to be taken in bright sunlight, a shade or hood is almost essential for use with those digital cameras that use the LCD screen as viewfinder. The tilting or swinging screens present on some of the more sophisticated cameras help in viewing the image to a certain extent, but still have limitations. Even with DSLRs, a shade or hood is useful when using the LCD screen to check composition and exposure after an image (or series of images) has been obtained.

Choosing a suitable lens

Now that digital cameras are so widespread, it is important to bear in mind that they function best with lenses designed specifically for them. This is particularly important with DSLRs with their interchangeable lenses. As mentioned earlier, sensors have a microscopic, approximately hemispherical, lens over each individual pixel. A portion of any light that strikes the edge of such a microscopic lens at an angle is reflected away and may be captured by an adjacent pixel. This can lead to a loss of resolution and contrast or even to colour fringing. Lenses that have been specifically computed for digital sensors produce an exit beam, the rays of which are closer to the parallel than those that are given by conventional (film) lenses, and are thus far less prone to this effect. Although you may use many older lenses on DSLRs, you may lose certain functions, such as autofocus and exposure control.

▼ If you have a film or digital SLR, then a huge range of lenses will be available to you.

The standard lens on most 35mm film cameras has a focal length of 50mm. This focal length came to be the accepted norm because it gives a field of view that approximately corresponds to that of the human eye (excluding the less distinct peripheral vision). Such lenses have a typical angle of view of 47° across the diagonal of the frame. Because of space considerations, many compact cameras are fitted with lenses with shorter focal lengths, usually 40 or 35mm, and a typical 3x zoom lens on a compact camera may have a range of 35–105mm. With digital cameras, the sensors are usually considerably smaller than the area of a 35mm film frame. To give the same field of view, the focal length of a lens designed for a digital camera therefore needs to be shorter. This does have advantages, in that the lens may be smaller and lighter than a comparable lens for a 35mm film camera. For the two most common DSLR sensor sizes (the APS-C and the 4/3 sensors), the actual focal length of the lens should be multiplied by 1.5 or 2, respectively, to obtain the 35mm film equivalent. This means that standard focal lengths are considered to be about 35mm or 24mm respectively; for example, the standard zoom lens on my Olympus DSLR, which uses the four-thirds (4/3) sensor, is 14–54mm, which is equivalent to 24–108mm on a 35mm film or full-frame camera.

▼ A 35mm lens is considered the standard focal length for the majority of DSLRs.

▶ A portion of a 22° halo: a full-frame image, photographed with a 50mm lens on a 35mm SLR.

▶ A double rainbow, photographed with a standard 50mm lens, with a polarizing filter (which has caused the darkening at the corners of the frame). Even though the bow is less than a full semicircle, it is obvious that the full extent of the primary (inner) bow extends well beyond the frame. The faint secondary (outer) bow is considerably larger. Other images of this rainbow are shown on page 33.

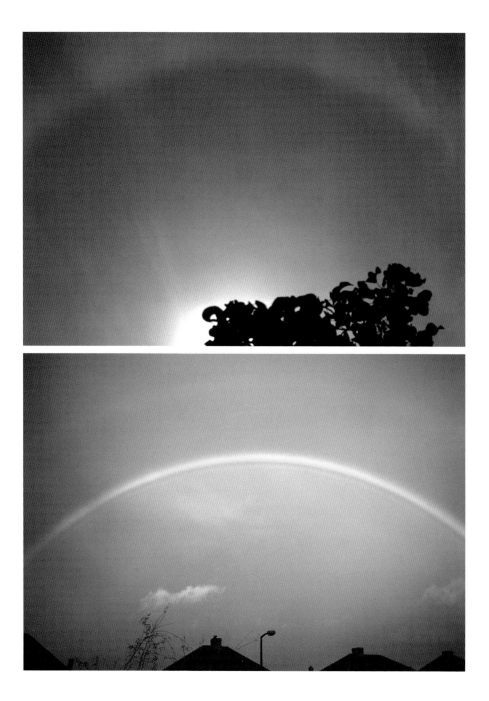

A wideangle lens has a greater angle of view than that of a standard lens. For 35mm cameras, typical wideangle lenses have focal lengths of 35 or 28mm, with fields of view of approximately 63° and 75° across the diagonal. The digital equivalents will, of course, have correspondingly shorter focal lengths.

Although many weather subjects may be adequately photographed with a standard lens or a mid-range zoom, a wideangle lens is undoubtedly highly desirable. It is not generally appreciated how large some of the sky's optical phenomena may be; for instance, the approximate diameters of five large optical effects are:

Primary rainbow	**84°**
Secondary rainbow	**102°**
Fogbow	**84°**
22° halo	**44°**
46° halo	**92°**

From these details it is easy to see that even the most common circular halo (the 22° halo) cannot be captured in its entirety with the 50mm lens that is supplied as standard with many film cameras, and which has a typical angle of view of 47° across the diagonal. In most cases, too, such a halo would fall just outside the wideangle range of the zoom lenses supplied as standard with many digital cameras.

The visible extent of rainbows and fogbows depends upon the altitude of the Sun, and the figures quoted assume that the Sun is on the horizon (in other words, at sunrise or sunset), when the full diameter is seen. Normally the angular separation between the two ends of a rainbow or fogbow will be much less, but even so, a wideangle lens will usually be required to show the full arc. On rare occasions, when the conditions are perfect, it is even possible to see a complete circular rainbow from an elevated position, such as from a mountain or an aircraft. Under these circumstances, although a wideangle lens would capture the width of the bow, an ultra-wideangle lens would be required to include the whole of its vertical extent. Digital processing offers the possibility of combining two or more images, but these optical phenomena are relatively diffuse, so the use of a stitching function can be difficult (see the discussion of combined and panoramic images on pages 136–7).

◀ Because many DSLRs use cropped sensors new wideangle lenses with extremely short focal lengths have been designed.

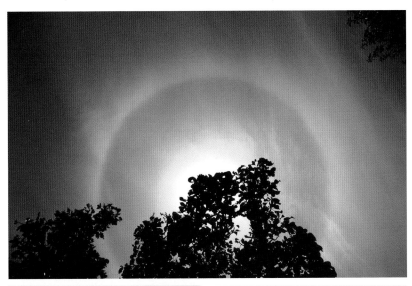

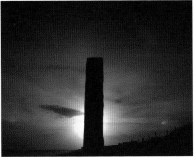

▲▲ The same 22° halo as shown on page 23, but photographed with a 24mm lens. This full-frame image shows how even with this wideangle lens, the halo would only just fit within the height of the frame.

▲ A full-frame image, taken with a 24mm lens, of twin parhelia, low down towards the horizon. They lie on, or just outside, the location of the 22° halo, if one were visible.

kit
fisheye lenses

Fisheye lenses are extreme wideangle lenses that offer a diagonal angle of view of 180° and are available in rectilinear and circular types. Rectilinear lenses warp the image into a rectangle, while circular fisheye lenses create a round image surrounded by a black margin. They are useful for taking whole-sky images, indeed this was their original purpose; however, the resultant distortion is not to everyone's tastes.

Telephoto lenses

Telephoto lenses are those with a narrower angle of view than a standard lens. Their focal lengths typically range from 85mm (or the digital equivalent) upwards. Lenses with focal lengths of 250mm or more are often known as super-telephoto lenses, but these are often heavy and cannot be hand-held, requiring the use of a support.

For weather photography a wideangle lens should be the first choice when supplementing any camera's standard lens, but a telephoto lens, although used less frequently, is also desirable. Some optical phenomena are relatively small, and a telephoto lens will enable subjects such as glories (page 97) and parhelia (page 103) to fill a larger portion of the frame. It is also useful to have a telephoto capability – whether a specific telephoto lens or a telephoto converter – in case one encounters some of the rarer phenomena, such as Kelvin-Helmholtz waves (page 87), which it would be extremely disappointing to find too far away to be photographed well. A telephoto lens that may be successfully hand-held is probably the best choice.

Alternatively, a high-quality teleconverter may be chosen. These will typically increase the available focal lengths by a factor of 1.4 or 2, although they generally decrease the maximum aperture provided by the primary lens.

◄ A telephoto zoom such as this 70—200mm zoom can prove useful, while being short and light enough to hand-hold.

Zoom lenses

Zoom lenses are those that offer a range of focal lengths (and thus angles of view). Although once regarded as offering poorer optical quality than fixed-focal length (prime) lenses, modern zoom lenses are of remarkably good quality, and have become almost standard with digital cameras, including DSLRs. It is important

to bear in mind that any zoom lens performs best in the middle of its range, where it shows least distortion. It is also the case that it normally gives the most even illumination at a moderately small aperture (usually around f/8 to f/11) rather than at either extreme of its aperture settings. These considerations are particularly important when taking a series of images that are to be combined into a panorama.

Because weather subjects often require you to shoot close to the Sun, the limitations of lens hoods need to be recognized. The lens hoods provided by the lens manufacturers cannot be ideal at all focal lengths. Generally, they cater for the shortest focal-length setting – although some cause slight vignetting when the lenses are used at the extreme wideangle setting. At longer focal lengths they may not provide as much protection as a lens hood designed for a fixed-focus lens. It is a good idea to cultivate the habit of checking for possible flare when shooting anywhere near the Sun (and, on occasions, near the Moon).

Macro lenses

A macro lens is one designed for close-up work, where the actual image on the film or sensor is life-size or larger, and where the final image on screen or in print will be larger than life-size. It might be imagined that there are no weather subjects that would benefit from the use of a macro lens, but this is not the case. Objects covered in dew and frost; drops of dew themselves (which may display tiny images of other objects or brilliant miniature spectra); ice crystals; and frost patterns are just a few of the subjects that may require a macro lens. It is not always practical, however, to carry a dedicated macro lens at all times. One of my great regrets is not having one to hand when I came across some ice crystals that had fallen during the night, which were tiny, six-pointed stars millimetres across, with perfect, minute hexagonal holes in their centres.

▶ Macro lenses are not a 'must have' when you are a weather photographer, but there are certainly some situations when they are handy.

Filters

The filters that are useful when photographing weather phenomena are just the same as those that employed for general landscape photography: ultraviolet (UV) filters, skylight 1A or 1B filters, graduated filters and neutral density filters.To these may be added polarizing filters, which are discussed separately.

Ultraviolet filters are needed when photographing at altitude, such as in the mountains, when they will reduce the overall blue cast. Their effect is hardly noticeable at low altitudes, although they may still be required when photographing near the sea or with snow-covered landscapes, where the amount of invisible UV light may be somewhat higher than normal.

Skylight filters serve a similar function to UV filters, except that they have a slight pink tinge, and will reduce the bluish colour cast and warm the image slightly. They are often employed to act as haze filters, when they reduce the blue tint seen on distant objects which gives rise to aerial perspective. They will not, however, reduce what meteorologists understand as 'haze', which is the brownish colour cast produced by scattering due to dust particles in the atmosphere.

With most digital cameras the effects of these two filters may be reproduced by means of adjusting the white balance (WB). Generally, auto-WB will tend to show a blue cast. Depending on the model of camera, the WB settings may be expressed either as 'cloudy' and

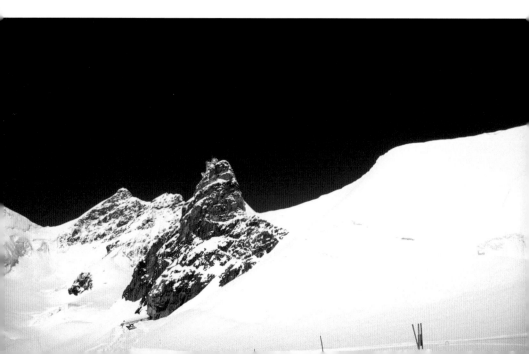

'shade', for example, or, alternatively, in terms of the colour temperature. In addition, some cameras allow adjustment of the colour balance of images stored within the camera, before transfer to a computer, where, of course, they may be further manipulated. With digital images it is, of course, relatively easy to remove an overall colour cast, particularly with RAW files, and some programs will adjust this automatically if required.

Because weather photography concentrates on clouds and the sky, exposures are generally best optimized for that part of the image. This may result in the foreground being underexposed and dark. If foreground objects are an important part of the composition, then a graduated neutral-

◀ Although a UV filter was used for this photograph, taken at the Jungfraujoch in the Swiss Alps at an altitude of about 3,400m (11,200ft), the sky has still been rendered an unnaturally deep blue, because of the extreme sensitivity of this particular Agfachrome transparency film to blue wavelengths. Despite use of the spot-highlight function, some detail has been lost in the brighter parts of the snowfield. The Jungfraujoch Observatory can just be seen on top of the dark outcrop of rock (known as 'The Sphinx').

density filter may help to produce a more even exposure over the whole frame. Their only slight disadvantages are that they may take a little time to mount and adjust, which may be significant should a particular phenomenon be changing rapidly, and that they may be used only when the division between sky and foreground is more or less straight. With digital cameras there is another option: take at least three photographs, with exposure settings for the sky, the foreground, and one or more intermediate exposures. The best exposures may then be combined at a later stage in the computer. Alternatively, where the foreground details are not of particular interest – and thus worthy of special attention – but where the whole image could do to be lighter, the brightness of the foreground alone may be adjusted with an editing program (see page 153).

Plain neutral-density filters are generally not used for the same reason that they are primarily employed in landscape photography: extending exposures to obtain a sense of motion in flowing water, such as waterfalls. Instead they may be employed to extend the exposure times when trying to capture images of lightning strokes. In this respect they are particularly useful during daylight hours, when the level of general illumination restricts the time that the shutter may be kept open.

Polarizing filters

A polarizing filter is an invaluable asset when photographing any aspect of the weather – indeed it may be said to be indispensable. It will cause some slight light loss, but it may be mounted on the lens more or less permanently, and removed only when conditions demand the maximum aperture or shutter speed.

Polarizers may be used on both film and digital cameras. They are so useful that it is worth experimenting with them even if your camera does not have provision for either a threaded or slot-in filter mount. The filter may be turned in front of one eye to judge the effect, and then held – with the same orientation – in front of the lens while the exposure is made. This may not be ideal, but provided the camera is held steady (preferably on a tripod), perfectly acceptable results can be obtained.

There are two types of polarizing filters: circular and linear. Nowadays, the former are more common and are preferable, because linear polarization may affect the exposure-metering system on some cameras. Even more importantly, linear polarization can cause significant problems for many autofocus systems.

Polarization is a complex topic, however, and some atmospheric phenomena and objects may differ in their appearance when viewed through linear or circular polarizers, so linear filters should not be rejected out of hand. If one is used, however, it would be as well to bracket exposures and switch to manual focusing in the case of a film camera, and to check exposure and focus on the rear LCD monitor when using digital equipment.

The inexpensive, plastic polarizing sheet available from scientific suppliers is normally a linear polarizer and may be used if a proper photographic filter is not to hand. A piece is also useful for examining details of a scene by eye, rather than through a camera's viewfinder or on an LCD screen.

Polarizers have five main uses when photographing the weather: controlling reflections, determining the visibility (or otherwise) of specific features, controlling the darkness of the sky background, affecting colour saturation, and haze reduction.

Controlling reflections

In general photography, polarizing filters are frequently used to suppress reflections from glass and other surfaces. The light reflected from the sea, lakes or pools of water is polarized to a greater or lesser degree, depending on which area of sky is being reflected and the angle at which the rays of light strike the surface. With still water, elimination of the reflections will darken it and may even reveal the bottom of shallow pools and puddles. With roughened water, a polarizer may eliminate most of the waves, which may not be desirable because it occasionally leads to an unnatural appearance.

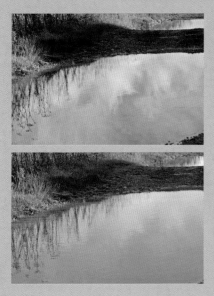

▲ Reflections, with (top) and without (bottom) the use of a polarizer.

Sometimes, too, the reflections of clouds, trees or other elements enhance the pictorial effect. There is a tendency to forget that a polarizing filter may help to accentuate (rather than remove) such reflections, and its effects are therefore always worth trying.

▲ These two images illustrate the degree of difference that the change in orientation of a polarizer may make. Here, the polarizing filter had been rotated by 90° between the two exposures. Apart from the fact that the nearer line of clouds has become extremely dark in the bottom image, the change in visibility of specific cloud features is particularly striking.

Visibility of details

The light reflected from clouds (in particular) and produced by many atmospheric optical phenomena is often polarized – sometimes extremely strongly. Depending on the direction of illumination and the orientation of the polarizer, you may (for example) obtain white clouds on a deep blue sky or dark grey clouds on a pale blue sky. Similarly, individual features of a cloud – which are often the main source of interest – may be accentuated by using a filter. It may be necessary to compromise between showing those features and creating a pictorially dramatic contrast with the surrounding sky.

Certain optical phenomena, such as glories (page 97), are polarized and therefore show differences – sometimes extremely subtle – in appearance with

changing orientation of the polarizer. Other, apparently similar phenomena, such as coronae (page 97) are not polarized, and some, such as rainbows (page 102) and various halo arcs (pages 103–4) are polarized in such a way that portions may disappear with particular orientations of the filter. A parhelion (page 103) actually shifts its position as the polarizer's orientation is altered. When these effects are combined with the way in which certain colours are accentuated by a polarizer, as described shortly, the answer is to experiment.

▼ A polarizing filter was needed to bring out detail in the altocumulus clouds in these two wideangle photographs. This has resulted in the top left-hand corner becoming dark in both, but this is less obtrusive in the bottom photograph, where there is cirrus cloud in that part of the frame.

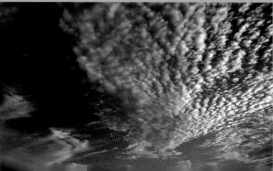

The darkness of the sky background

Scattering by the molecules in the air causes even a clear blue sky to be polarized. But this is not uniform: The greatest polarization occurs at 90° from the Sun, but there are three neutral points where there is no polarization: Arago's point – 20° above the antisolar point; Babinet's point – 20° above the Sun; and Brewster's point – 20° below the Sun. The degree of darkening created by a polarizing filter therefore varies considerably across the sky. This is generally not a problem with telephoto or standard-length lenses, but may become noticeable with wideangle lenses and produce an uneven variation in the depth of colour of the sky across the frame. In many cases this may be ignored, but occasionally, depending on the exact lighting conditions, it may be extreme and obtrusive, appearing similar to vignetting. Although nowadays digital compensation may be employed, this is not always easy to apply, and it may be necessary to frame the image with later cropping in mind, or (once again) compromise on the amount of polarization introduced.

Colour saturation

Because of the way in which certain optical phenomena are polarized, changes in the polarizer's orientation may cause significant changes in the colour saturation. This is probably most noticeable in the case of rainbows, although it occurs to some extent in most coloured phenomena. Because

▶ This photograph, taken with no filtration, shows part of a primary (inner) and secondary rainbow. Alexander's Dark Band (see page 102) lies between the primary and secondary bows, while the narrow band inside the violet strip is a supernumerary bow.

▶▶ This image of the same rainbow was taken with a polarizing filter set to darken Alexander's Dark Band as much as possible. The colour saturation has increased, particularly the violet. This has produced a slightly unnatural appearance, and it is a matter of taste whether this is desirable.

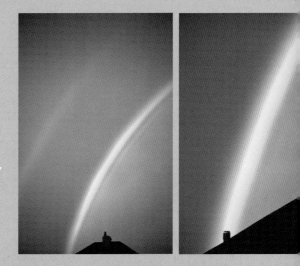

most of the shades of colour exhibited by atmospheric phenomena are quite subtle, major changes in the saturation can cause a picture to appear extremely unnatural, and be immediately obvious to anyone with a little experience. This may be of no consequence if the shot is being treated simply as a photographic image, but it is undesirable if the principal interest is a meteorological one. It is probably better, in such a case, to bracket exposures, which in itself will provide different degrees of colour saturation. If it is suspected that the phenomenon may be unusual or rare, then it is certainly advisable to record at least one image without any enhancement of the colours. (Some rare phenomena, where photographs would be of considerable scientific interest, are described later.)

Haze reduction

Part of a polarizing filter's effect on colour saturation is caused by the elimination of some of the light that is scattered by the atmosphere between the subject and the camera, thereby producing purer colours. However, some scattering is inevitable, and gives rise to haze and to the general effect of aerial perspective, whereby more distant objects take on a blue cast. A polarizing filter will block the scattered light and so may be regarded as fulfilling a similar function to a skylight filter, with the advantage that the amount of haze reduction may be controlled. In general, however, polarizing filters cannot be used when taking photographs from aircraft, trains or other vehicles, because of the spurious colours introduced by the panes of plastic or toughened glass in the windows.

Film

For those working with film, the main choice is between transparency or negative film. Transparency film is better at recording detail, tends to have greater colour saturation and finer grain than negative film, but has a more limited exposure latitude – in other words it will not record detail over such a wide range of brightness as negatives. This means that correct exposure is more critical. It is a matter of personal preference whether one prefers saturated films, such as Fuji's Velvia and Kodak's Kodachrome, or the 'softer' Fuji Astia and Kodak Ektachrome films.

Negative films have a greater exposure latitude, and are thus more tolerant of slightly incorrect exposure, but prints invariably show lower contrast than a similar image on transparency material. The main advantage, of course, is the fact that prints are easy to obtain and are convenient to show to others. It should, however, be borne in mind that a relatively cheap transparency scanner may be used with a computer and printer to produce perfectly acceptable prints at a moderate size.

▼ A scan of a print (left) and a subsequently adjusted image (right), showing increased contrast.

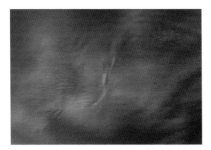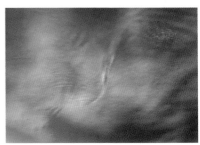

Film speed

The majority of weather photographs are likely to be taken in daylight, so extreme speeds are generally unnecessary. Weather photographs often include large areas of relatively even tint, where grain is most apparent. Slow to medium-speed films are therefore generally the most suitable, such as Kodachrome 64, Fuji Velvia 50, or Ektachrome Elite 100 among transparency films. The majority of negative films nowadays have film speeds of ISO 200 or greater, one of the few exceptions being Fuji's Reala at ISO 100.

Digital memory

There are several forms of digital memory card, and the type required is dictated by the camera, although some do make provision for more than one. The capacity that you require will depend, to a certain extent, on how you expect to process the images that you obtain. If you believe that you may – at least on occasion – carry out a considerable amount of subsequent editing on computer, it will usually be best to record images in a RAW format. RAW files are much larger than even high-quality JPEGs, so you can fit fewer on a card.

It is sensible to have more than one memory card, but you should bear in mind that although memory cards with large capacities appear highly desirable, some have longer write times than smaller-capacity cards. High-speed, high-capacity cards are now available, and only slightly more expensive. It is also worth noting that there are some concerns over the long-term stability of solid-state memory cards, with the suspicion that they may degrade with time. In any case, it is sensible to transfer images to computer, and from there on to a more permanent form of storage.

Image transfer

Digital images may be transferred to a computer either through a directly connected USB or Firewire cable, or by fitting the memory card into a card reader. Most card readers accept more than one type of memory card, and may themselves be either of the internal or external type, the latter normally connected to the computer by a USB cable. With a direct connection between the camera and computer, it is crucial to check that any USB input meets the camera's requirements. Strange errors may occur during transfer if there is any mismatch. Such inconsistencies can also be caused by connecting a camera via certain USB hubs.

kit
microdrives

When they first became available, the increased memory capacity of microdrives offered a great advantage over solid-state cards, such as CompactFlash, but the latter now offer large capacities. Writing to and reading from microdrives is generally slower than with solid-state cards. They have greater power demands and thus reduce the time before the battery requires recharging. They are also less robust as they contain moving parts.

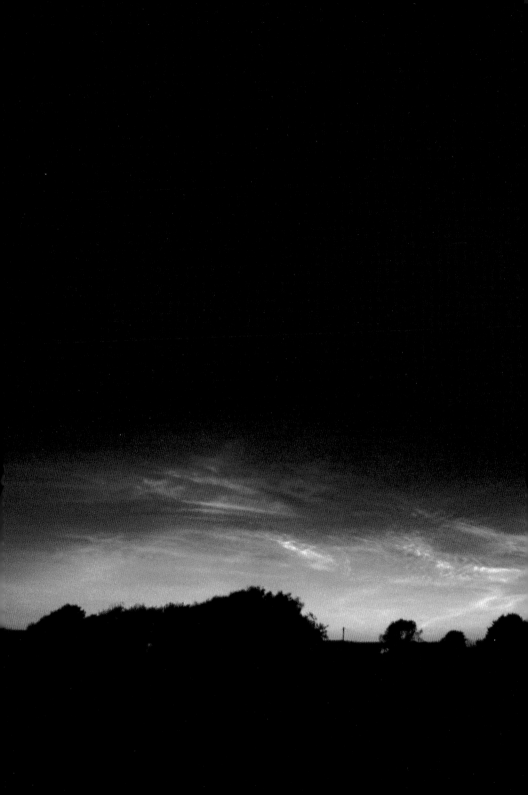

Chapter 2
Basic technique

While this book is principally about photographing the weather it's important to understand the basics of photography. This means that you should have the ability to control you camera and to know what it is doing; enabling you to take the pictures that you want. You can divide most weather photography into two types: creative and record. Creative photography places the emphasis on aesthetics, and being able to control exposure, focus, colour and composition will help you to impose the creative control that you require. Record photography, on the other hand, requires that you capture the scene as accurately as possible. This means that you still need to understand the basic techniques of photography so that you can capture an image that is essentially an accurate record. These two fields often overlap, and there is no reason why a creative image cannot be an accurate record, nor indeed that a useful reference shot should not be attractive. However, it is worth considering exactly why you are shooting a particular scene, and taking account of this when you are considering which techniques you are going to apply to the scene in front of you.

Exposure

Obtaining the correct exposure involves several different elements: the metering system; aperture settings; shutter speeds; and the sensitivity of the sensor or film. While most cameras now feature a vast array of metering settings, allowing you to shoot at will without worrying about technique, it is very useful to know what is happening. Automatic modes are great if you just want to point and click, but it helps to know how to manipulate your camera. This will give you the best chance of ensuring that you can come up with the goods, either by managing the camera to ensure that your image is an accurate record, or by applying the variables creatively in order to produce an image with impact. Understanding metering will help you to predict how the basic exposure will be calculated and what effect this has on the image you want to create; while the exposure variables of ISO, shutter speed and aperture allow you to manipulate the basic information to achieve different results. Through the information given here, and by experimenting in the field, you will hopefully be able to capture your images of the weather how you wish.

Metering systems

Nearly all modern cameras employ through-the-lens (TTL) metering, actually measuring the amount of light passing through the lens. This is then used, together with the current ISO speed rating, to calculate an exposure value (Ev), which is further processed to derive mutually interdependent values for shutter speed and aperture. The values are shown either in the viewfinder (or viewfinder screen) or on an LCD function panel. DSLRs usually provide both forms of read-out.

There are three basic methods of TTL metering, and most sophisticated cameras provide the means to switch between them so that the most appropriate may be used.

Multi-segment metering

In this system, readings are taken from several parts of the image, and the readings are combined to provide an overall value. This method is often the only one provided by many compact cameras. Some more sophisticated systems compare the distribution of brightness across the image with a number of 'standard' situations. In general, this works well in most situations, particularly where the subjects of interest are spread across the frame.

Centre-weighted metering

In centre-weighted metering, exposure values are calculated across the whole of the frame, but a central area is given

a higher weighting (usually 75%) than the periphery (25%). The central area is circular and is normally shown in the viewfinder. This is occasionally useful when there is an important central subject, but will generally be found to be less appropriate than spot metering.

Spot metering

In spot metering, a reading is taken from a tiny portion of the image, and this area (normally, but not always, circular) is marked in the centre of the viewfinder. This is by far the best method of establishing the correct exposure. In general, however, digital cameras are less flexible in this respect than some earlier film cameras. Digital cameras usually offer single-spot metering, which assumes that the area being measured has 18% reflectance. Using such metering on a brilliantly white snowfield would result in the snow reproducing as a dull grey. It will normally be necessary to set the exposure compensation to give about 2 stops greater exposure (normally shown as +2). Similarly, if you wish to show the metered area as completely black, rather than grey, you will need to set negative exposure compensation, again by about 2 stops (–2).

The better film cameras and some of the later digital cameras have multiple-spot metering, where the exposure is determined by setting the metering area on a number of important points of the subject, from which the camera calculates the optimum exposure. Even better control was offered by the Olympus OM series, where certain models had highlight spot metering, which was useful for weather subjects. The brightest part of a cloud or snowfield could be set to reproduce as pure white, without the risk of overexposure losing detail in fainter areas of the image. Shadow spot metering was also available, although less often required. Olympus has now reintroduced highlight and shadow spot metering on some of its DSLRs.

▶ For general scenes the multi-segment metering mode that is the default system on most cameras should be adequate.

Once a camera's meter has measured the amount of light that is required to expose the scene, the camera, or you, can put this into action with a combination of exposure variables. The aperture (the size of the opening through which light is admitted to the sensor or film) and shutter speed (how long the shutter is left open) are the two factors that determine the amount of light reaching the film or sensor; the amount of light required depends on the ISO rating of the film or sensor. These three variables are interdependent, in that for a given exposure value (in other words, the amount of light required to record an image), varying one factor inevitably requires an equal but opposite alteration in the other. These changes are referred to in terms of 'stops'. A decrease in aperture from (say) f/5.6 to f/8 is described as a one-stop reduction in aperture. Similarly, a change in shutter speed from 1/125 sec to 1/250 sec is a one-stop increase in shutter speed. Each individual variable is considered on the following pages.

Aperture

The amount of light passing through a lens is controlled by a diaphragm with a variable opening. The size of this opening is related to the focal length of the lens, and calibrated as a scale of f-stops, where the f-stop is the ratio given by the diameter of the aperture, divided by the focal length. For a focal length of 100mm, for example, an aperture of 25mm would give a ratio of 25/100 or 1/4, expressed as f/4. An alteration in aperture from f/4 to f/5.6 (a decrease in aperture size of one stop) would reduce the amount of light falling on the film or sensor to one half of the original amount. With a zoom lens, of course, with a fixed aperture, the f-ratio varies as the focal length is altered.

All lenses are calibrated to the same scale, and the values are shown on the aperture ring of the lens if it has one. In modern cameras, the specific value at any one time is shown on the LCD panel or in the viewfinder (or both). Depending on the camera, it is normally possible to set values that are intermediate between the main f-numbers, so that the aperture may be varied by half or even one-third stops.

It should be noted that lenses generally perform best in the central portion of their aperture range. A lens with an aperture range of f/2.8 to f/22, for example, might provide the best definition and least distortion between f/8 and f/11.

Shutter speed

As with apertures, the basic shutter speeds are arranged to give one-stop increases or decreases in exposure. The actual values may not appear to be exactly twice or half of the next value, but in practice the one-stop difference is preserved. A typical range for a modern DSLR is 1/4,000sec to 60sec, with a bulb ('B') setting allowing longer exposures, usually up to a specific limit of about 6–8 minutes. The most sophisticated cameras allow shutter speeds to be increased or decreased in half or one-third stop steps.

The majority of weather subjects do not show rapid motion, so shutter speed tends to be of less significance than aperture. One exception comes when photographing storm-force waves, where it is generally most effective to use a fast shutter speed to freeze the motion. But probably the most important consideration is to use a fast shutter speed to minimize camera shake. Although most weather subjects are at infinity and thus do not readily reveal small amounts of camera shake, it is nevertheless to be avoided at all costs. I am always reluctant to hand-hold a camera at any speed slower than about 1/125sec, or 1/60sec at a pinch, and prefer to open up the aperture instead if I have no tripod or other form of camera support available.

kit
tripods

Tripods, and indeed any kind of camera support, are very useful when shooting a slow shutter speeds, as they will help prevent camera shake. Because of the relationship between shutter speed and aperture they are also a good way of ensuring that you have the full range of apertures available, which can be important if you wish to include the foreground in your image.

▼ Using a fast shutter speed, such as 1/500sec in this case, allows you to freeze fast motion rendering it sharp in the final image.

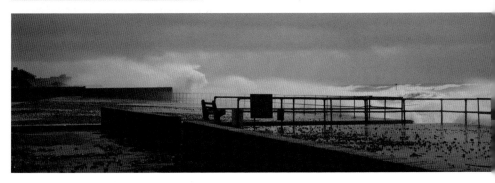

ISO rating

The speed ratings of transparency and negative materials has been mentioned earlier (see page 34), and once set on the camera these are rarely altered unless circumstances demand using the film at a different rating and altering the processing to produce the equivalent of a higher speed. With digital cameras, however, it is simple to alter the sensitivity of the sensor. Rather than using an larger aperture, for instance, one could increase the ISO rating (say) from ISO 100 to 200. This method should be used with caution, however, because sensors are prone to greater noise when their sensitivity is increased, particularly after ISO 400.

kit noise

The variation of the signal of individual pixels away from their true value is known as noise. This is visible in the final image as individual pixels that are lighter or darker than they should be. This tends to be a greater problem the higher the ISO value that you use; it also tends to be more of a problem on those cameras that have smaller sensors with very high resolutions.

▼ A high ISO rating has allowed this image to be taken in low-light conditions, although some noise can be seen.

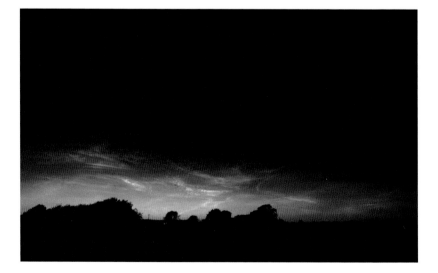

Exposure modes

There are various exposure modes that may be available with both film and digital cameras, and mid-range and SLR cameras usually offer a choice of which mode is used. Some compact cameras may not allow for a choice. Many cameras offer a range of situation-specific modes, these are fine to get you started, but leave you very little control. Such modes include landscape modes, night modes and even sunrise/sunset modes although the name of each will vary depending on the manufacturer of the camera. What these exposure modes do is choose apply the meter reading obtained to a predefined set of instructions; for example, a landscape mode will try to set a relatively narrow aperture so that there is a larger depth of field and everything is sharp, while a sunset mode might use a white balance that retains a lot of warmth in the colours and set a high level of saturation to give those colours more punch. These are great ways of getting started, but ultimately they take the creative decision making away from you. For that reason the following four exposure modes – manual, program, aperture-priority and shutter-priority – are better suited to the enthusiastic weather photographer as they offer greater control over the final image.

Manual mode

Most cameras, except the simplest 'point-and-shoot' types allow you to switch to manual control of aperture and shutter speed. This is often extremely useful when dealing with difficult subjects, and especially those where you wish to achieve a specific effect. The more sophisticated cameras provide a viewfinder or LCD panel indication of whether the values that have been set manually will result in over- or under-exposure relative to the settings that the metering system would set automatically.

▼ The manual exposure mode is the most flexible, although it is also the most demanding.

Program mode

In program mode, the camera will automatically select the aperture and shutter speed according to parameters set by the metering system. Generally such programs begin, at the lowest exposure values, by selecting the largest aperture and maintaining that aperture, but increasing the shutter speed with increasing exposure values. At a certain shutter speed, the program will switch to decreasing the aperture and simultaneously increasing the shutter speed to allow for the increasing brightness of the image.

In general, program modes cope fairly well with most meteorological subjects, although they commonly underexpose foregrounds and overexpose clouds and other phenomena. If possible, it is best to establish the exposure by pointing the camera at the main subject, then locking the exposure and re-composing the picture. Given that on many occasions clouds and the sky are much brighter than any foreground, and are the main subject of interest, it is usually best to expose for the former.

If foreground details are important and add significantly to the appeal of the final image, then a little more trouble should be taken. If the division between the sky and foreground is reasonably straight, a graduated neutral-density filter (page 29) may be used to equalize exposures. With digital images, and especially if there is a great difference in brightness, the best solution is undoubtedly to take two or more photographs, using the optimum exposure for each portion (and perhaps an intermediate setting as well), and to combine these at a later stage in the computer. The automatic bracketing function available on some digital cameras is also useful in this respect.

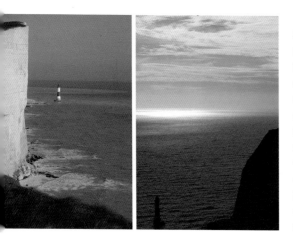

◀ These images help to illustrate the limitations of program modes. In the right-hand image of Beachy Head lighthouse off the south coast of England, the program mode set the aperture to f/8 and the shutter speed to 1/500sec. The result is far too dark, unless a moody image is required. A positive compensation was called for. In the second image, even though the cliffs were brighter, the program mode set a larger aperture of f/5.6 and a shutter speed of 1/250sec, with a far better result.

Aperture-priority mode

In aperture-priority mode, the camera selects the optimum shutter speed for the aperture that you select manually. For weather photographs, this mode is most suitable when you wish to exert control over the depth of field – when shooting close-ups of dewdrops, for example, when you want the background to be out of focus; alternatively, if you are including both foreground and sky then it can be useful to use a narrow aperture for a great depth of field. If the camera has a depth-of-field preview function, this may be used to judge the correct aperture setting, although with digital cameras it is easy enough to make several exposures with different aperture settings, and select the most suitable.

Shutter-priority mode

In shutter-priority mode, the camera selects the best aperture for the shutter speed that has been chosen manually. This mode is not often required for photographs of the weather but, as mentioned previously (page 41), may be used to freeze spectacular waves when photographing storm conditions on the coast. If a subject includes running water in the foreground, you may wish to use shutter-priority mode to force a slow shutter speed – ideally with the camera on a tripod – to give a greater sense of motion to the flowing water.

▼ This photograph, shot in program mode, illustrates the common problem of a correctly exposed sky, but underexposed foreground.

There are two common ways to adjust the overall exposure value: compensation and bracketing. Compensation is usually applied in situations where you require the camera to compensate for a factor that you are aware of, but the camera may not expose properly for; while bracketing is generally used in situations in which you are uncertain of the exposure and you need to have a number of different exposures to choose from.

Exposure compensation

Exposure compensation may be required when dealing with subjects that are brighter or darker than 'average' images. With a bright scene, such as a snowfield, following the values set by the automatic exposure system would produce an image that is too dark, because (as discussed earlier under spot metering, page 39) the assumption is that subjects are of average (18%) reflectance. With bright subjects, compensation will be needed to give greater (positive) exposure. In the case of snow, the optimum compensation is likely to be about 2 stops greater exposure. Similar considerations apply to dark subjects which require negative compensation.

Bracketing

When dealing with a difficult subject, perhaps one where there is a great range of brightness, shots taken at dawn or dusk, or with backlit subjects, it best to bracket exposures, taking one or more shots with positive and negative compensation on either side of the value indicated by the automatic system. With digital cameras, where the results may be examined immediately, this method is particularly easy and effective. With film you have to resign yourself to 'wasting' some film. Some digital cameras have an automatic bracketing function. When this is switched on, each depression of the shutter release will, depending on the camera, produce a series of images (usually three or five) with different apertures or shutter speeds – the variable that is changed depends on the mode. Many DSLRs have a similar white-balance bracketing mode, where the camera captures a series of images with different colour-temperature settings (see pages 12–13).

▼ A bracketed sequence of images that shows negative compensation (left), the recommended meter reading (middle) and positive compensation (right).

kit
highlight indication

Some high-specification digital cameras may be set to show overexposed areas (usually blinking) when an image is displayed on the LCD screen, but implementing this facility is often rather long-winded and cumbersome, and it is normally probably simpler to bracket exposures and choose the best image, or to use the histogram display (described right). Note, however, that the highlight display shows only those areas where the pixels have been saturated ('burnt out'), so it is not a substitute for highlight spot metering.

kit
histogram display

Many digital cameras provide for the display of information relating to each image, such as date and time of exposure, number of pixels, data compression ratio, and so on. The most useful display is the histogram display, which shows the distribution of brightness in the image. If the peak of the display is towards the right, the image is probably too bright; towards the left, too dark. In the first case, negative compensation is required, and in the second, positive. Alternatively, you may wish to try the effect of re-composing the image.

Exposure: general considerations

It is important to bear in mind that digital cameras usually operate at a relatively low ISO-equivalent speed rating (normally ISO 100). Except under bright conditions with high exposure values, program modes are likely to set a fairly wide aperture, which may not give optimum quality, especially with zoom lenses. Wide apertures may also lead to vignetting on wideangle lenses. Under dark and low-light conditions you may wish to switch to aperture-priority mode. Very long exposures may reveal certain problems with image noise, and some correction (see pages 14–15) may be required.

Although with digital images or scans of transparencies or negatives, or scans of prints, compensation may be made at a later stage for slight errors in exposure, it remains true that optimum exposure at the time the photograph is obtained will record the greatest detail. Some detail may be lost if too great a reliance is placed on automatic exposure systems or later computer processing.

Focusing

A major factor in the success of any photograph is that the primary subject should be in correct focus. Technically, only objects at one specific distance from the lens are in focus at the same time, and objects that are slightly farther away, or closer to the camera are out of focus. However, the human eye is unable to detect extremely small deviations from correct focus, and the range of distances that appear sharp is known as the depth of field.

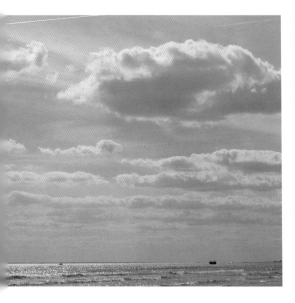

▲ Although this image appears to present no great difficulty for autofocus, in fact it was necessary to move down to the horizon to get the AF to operate. That focus was held while the image was reframed.

Autofocus (AF)

Most modern cameras have an autofocus system using a small area (or areas) of the image as the target. The target areas are shown in the viewfinder, normally coincide with the very centre of the image frame and to its left and right, often close to the edge of the area used in centre-weighted metering (see pages 38–9). Many cameras allow you to alter which target areas are used.

As with automatic exposure, weather subjects sometimes present problems for autofocus. The most common causes are:

- low contrast
- an extremely bright area in the centre of the field
- subject outside the AF target areas
- fast-moving subjects
- subjects at distinctly different distances
- repeated patterns

The first three of these are those that are most likely to give problems with weather images. Low-contrast subjects often occur, typical subjects being a landscape in fog, evenly lit sky, or clouds with little obvious structure. If the Sun (or even occasionally the Moon) appears in the centre of the frame it may prevent the autofocus from obtaining a lock, as will a brightly illuminated cloud that is in sharp contrast with its surroundings. Frequently, too, the main

subject (clouds, say) may be to one side of the frame and the centre occupied by featureless sky. It is always slightly annoying when one tries to take a picture and the AF system does not work. The majority of subjects are at infinity, so there are two options: use manual focusing or focus lock.

Focus lock

Most autofocus systems give an audible signal and a viewfinder indication when they have obtained accurate focus. They generally focus and then lock the setting when the shutter-release button is depressed halfway. A locked focus is often indicated by a flashing signal in the viewfinder. While holding the button partially depressed, you can then reframe the subject. With weather subjects that are at infinity, it is usually possible to bring a distant portion of the horizon to the centre of the field, and lock that focus. However, manual focusing is often the better solution, especially if you want to take a series of photographs – such as for a panorama – or if the actual subject is at an intermediate distance and there are no other objects at a similar distance on which one may focus.

When taking more than one image of a specific subject at different focal lengths with a zoom lens, it pays to bear in mind that even with the best lenses, the focus may alter slightly as the zoom is used. Do not expect the infinity setting to be exactly the same throughout the range. This is particularly important under low-light or night-time conditions, when any AF facility is likely to be unreliable. Manual focusing, however, may be difficult because the image seen through the viewfinder or on the LCD screen is dim. Turning the focusing ring to the end of its travel may actually take it slightly past the optimum position for infinity. The problem is most likely to arise when going from short-focus (wideangle) to long-focus (telephoto) settings. If focusing is difficult, it is worth making an effort to obtain correct focus at the telephoto end of the range, and then keep that focus setting when using the zoom to change to a wideangle shot.

Manual focusing

Manual focusing is often the simplest method of obtaining correct focus, but even this may sometimes be difficult under foggy conditions. Night-time photography and photographing a very dark subject may also pose difficulties. Other than on most compact cameras, if the lens is a prime lens it will probably have a depth-of-field scale, indicating the distances that are in focus when used at a particular aperture. The aperture may be read from the LCD display and the focus then set using the scale.

Depth of field

Three factors are significant in the depth of field of any given lens (in other words the range of distances at which the focus appears sharp): aperture, focal length and subject distance. Their effects may be summarized as: a small aperture, short focal length and a great subject-to-camera distance increase the depth of field; a large aperture, long focal length and a short subject-to-camera distance decrease the depth of field.

Because the majority of weather subjects are at infinity, depth of field is rarely a major concern. You may, however, want to frame a distant subject with nearby trees, an archway, or some similar object, that should be out of focus. Similarly, a close-up of a subject such as frost crystals would be improved if the background were out of focus. With fixed-focal-length lenses a scale is often provided to show the range of sharp focus for any given aperture. Some cameras (particularly high-specification SLRs) provide a preview button, which closes the aperture to the size to be used for the exposure so that the depth of field may be seen directly. Unfortunately, this reduces the brightness in the viewfinder, which may make it difficult to determine whether the effect will be satisfactory. With digital cameras it is probably easiest to make a trial exposure and examine the result, using the image magnification function on the LCD (if the camera has one).

◀ A relatively straightforward photograph, because all the important elements may be considered to be at infinity. Only if there were large foreground waves, would much attention have to be paid to the depth of field.

Colour temperature

Colour temperature has been described earlier (see page 13). Although in the majority of cases weather photographs use natural light, this varies considerably throughout the day. Because our vision tends to compensate for changing colour temperatures, we do not always appreciate that significant alterations have taken place. This leads to the perennial discussion of whether adjustments should be made around sunrise and sunset, when (without correction) colours will usually appear more lurid than those that are perceived by the eye. With weather subjects there seems little reason for making such corrections. Some correction may be worthwhile if there is some foreground object that might otherwise dominate the picture because of its vibrant colour, or for other aesthetic reasons.

Natural lighting

Adjustments to the way in which colours are recorded are made with filters in the case of film, and by altering the white balance on digital cameras. The approximate colour temperatures of natural lighting that are likely to prevail at various times over the course of the day are as follows:

- sunrise and sunset: 3,000–3,100K
- 1hr after sunrise and 1hr before sunset: 3,500–3,700K
- 2hrs after sunrise and 2hrs before sunset: 3,850–4,000K
- mean sunlight at noon: 5,400K
- photographic daylight: 5,500K
- overcast sky: 7,000K
- clear sky (open shade): 10,000K
- skylight: 12,000–18,000K

kit
photographic daylight

The term 'photographic daylight' applies to films. It is an average value for which daylight films are balanced, and which will give reasonable results at any time of day.

► As you can see a lower colour temperature at the end of the day has added a warm glow to the bottom image, compared to the top one.

Chapter 3
Understanding weather

Although it is not necessary to have a profound knowledge of meteorology to take weather-related photographs, a basic idea of the mechanisms by which weather and climate are produced is, nevertheless, extremely useful. It helps you to know when and where particular types of cloud or optical phenomena are likely to occur, how they may change, and the likelihood of being able to photograph them.

The layers of the atmosphere

The weather that dominates our lives, and the majority of clouds worth photographing, are largely confined to the lowest layer of the atmosphere, known as the troposphere. In it, there is an overall decline in temperature with height, as far as a level called the tropopause. This separates the troposphere from the overlying stratosphere, where the temperature initially remains steady and then begins to increase with height. The height of the tropopause varies with the season and with latitude. It is roughly 14–18km (8½–11 miles) in equatorial regions and 5–8km (3–5 miles) at the poles, where it is often ill-defined during the winter.

The tropopause is not continuous from equator to poles. There are major changes of level and breaks at latitudes 30° N and S, and also farther towards the poles at the general location of the polar fronts, where warm air from the middle latitudes encounters cold air from the poles. (The importance of fronts and the clouds that are associated with them is discussed a little later.)

◀ This image, taken from a Space Shuttle, shows cumulonimbus clouds silhouetted against the sunrise. Their anvils have spread out at the tropopause, which is here about 12–15km (7½–9 miles) high.

Inversions

Any layer in which the temperature increases with height (known as an inversion) acts as a barrier to the upward growth of clouds. The tropopause is a major barrier, and it is here that rising cells of cumulonimbus clouds are halted, spreading out to give their characteristic 'anvil' shape.

Depending on the routes that they take, and whether they are on short-haul or long-haul flights, aircraft may remain below the tropopause or cross through it into the stratosphere. This affects the types of clouds that are likely to be visible from on board and that may be photographed (see pages 118–121).

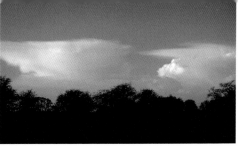

▲ Another image from a Space Shuttle shows major thunderstorms over Brazil. The anvil tops of these cumulonimbus clouds consist of large plumes of cirrus (ice-crystal) cloud.

▲ A pair of cumulonimbus clouds that have reached the tropopause and spread out into anvils. Here, the winter-time tropopause was relatively low.

Rather than a steady decline in the temperature from surface to tropopause, the rate varies considerably with height, and there may be one or more subsidiary inversions at different altitudes. These strongly affect the growth of clouds and often determine clouds types visible. Jet streams (see pages 64–5) are usually close to major breaks in the tropopause. They play an important part in the life of depressions, and their distinctive clouds are often easily visible from the ground.

Higher layers: the stratosphere and mesosphere

There are few clouds in the stratosphere, except occasional cirrus in the lowest part, or the rare nacreous clouds (see page 76). Between the tropopause and 20km (12½ miles), the temperature is fairly constant, but then increases, reaching its maximum at the stratopause, at about 50km (31 miles). Above this, in the mesosphere, temperature declines with height, reaching the atmospheric minimum at the mesopause – at about 83–103km (51½–64 miles). Just beneath the mesopause are noctilucent clouds (see page 77), the only clouds in the mesosphere, and the highest of all.

Although not, strictly speaking, weather phenomena, auroral forms are described here because they make for wonderful photographs (see pages 88–9). Aurorae occur high in the upper atmosphere at various altitudes, between 100 and 1,000km (62–620 miles).

▼ A homogeneous auroral arc, which usually occurs early in a display.

The general circulation

The basic cause of the Earth's weather is the unequal heating by the Sun of air in the equatorial region and that near the poles. Intense heating in the tropics causes the air to rise and produces large cumulonimbus clouds and, in particular, a band of cloud (known technically as the Intertropical Convergence Zone, ITCZ), clearly visible on satellite images. The air flows north and south from the equatorial zone at an upper level, but for complex reasons related to the rotation of the Earth, does not form giant, single circulation cells in each hemisphere reaching the polar regions. Instead, the air descends at latitudes of approximately 30° N and S, creating high-pressure, relatively cloud-free zones (the subtropical anticyclones) where the world's major deserts are located. For similar reasons, the air does not flow directly north or south, but instead is deflected towards the right in the northern hemisphere, and towards the left in the southern.

▼ A false-colour image showing the cloud along the ITCZ parallel to the equator, the clear skies in the sub-tropical high over the Sahara and Arabia, a line of Saharan dust blown over the Atlantic, and cyclone Gafilo off northern Madagascar.

Global winds

Some of the air from the subtropical anticyclones flows back towards the equator at the surface, forming the northeasterly and southeasterly trade winds. In each hemisphere, the remaining air flows towards the poles, also at the surface, forming the belt of mainly westerly winds that dominate temperate latitudes between 40° and 70° N and S. In the southern hemisphere, with only a few landmasses, the westerlies are particularly strong, forming the Roaring Forties, the Fearsome Fifties and the Screaming Sixties, encircling Antarctica. The dominant westerly winds mean that weather systems tend to move from west to east in both hemispheres. Although there are exceptions, as a rule, if you want to know what weather is coming, see what is happening to the west.

In each hemisphere, cold, dense air flows out of the polar regions as the polar easterlies, and these encounter the zone of westerly winds along an important atmospheric boundary, known as the polar front. The polar fronts do not lie at fixed latitudes, but occur as a series of waves, or lobes, which move around the Earth, with ridges of warm tropical air extending towards the poles and troughs of cold polar air reaching towards the equator. It is at the polar fronts that the major low-pressure areas or depressions (known technically as cyclones) develop. These tend to dominate the weather at temperate latitudes, and are borne eastwards on the westerly airflow. Depressions often offer the opportunity of photographing several different cloud types within a fairly short time.

▼ A false-colour Meteosat image showing a series of waves and incipient depressions along the polar Front to the west of the Bay of Biscay. Two major thunderstorm clusters are in mid-Atlantic.

weather watching
wind directions

Note that winds are always described in terms of the direction from which they blow. Thus the northeasterly trade winds blow northeast to southwest, and the westerlies, which are all-important for the weather in the temperate regions, flow from west to east.

Seasonal changes

The wind belts and the high- and low-pressure regions tend to move north and south with the changing seasons. The effects of the seasonal changes are greatly dependent on the distribution of land and sea, and give rise to the various types of climate that are encountered in the different parts of the world. A number of different climatic zones are recognized, primarily based on the temperatures that prevail in winter and summer, rainfall, and vegetation type, but for our purposes it suffices to consider just maritime and continental climates. Maritime climates, such as those that are found in western Europe, on the west coast of North America, southern Chile, and New Zealand, are characterized by comparitively low temperature ranges between summer and winter, and rainfall throughout the year. Continental climates, by contrast, such as those found in the interior of North America (particularly in Canada) and in Siberia, are extremely cold in winter, but liable to become very hot in summer. Here, eastward-tracking depressions from the Pacific bring large amounts of snow to central North America, but Siberia, being a great deal farther from the Atlantic, has a lower snowfall.

Air masses

When air is stagnant over a particular area (the source region) for a long period, it takes on specific properties, depending on the location. This gives rise to specific air masses with particular temperatures and humidities, which offer distinctly different photographic opportunities. An air mass tends to retain its characteristics when it leaves its source region, but gradually becomes modified, depending on the nature of the surface across which it moves. A cold, dry air mass that originated over northern Canada and Greenland, for example, will warm and become increasingly humid as it moves over the North Atlantic. It may therefore change from being a continental air mass to a maritime one, depending of the amount of time it spends on its travels and its precise original properties.

Equatorial air is sometimes designated 'mE', because it resembles maritime air with its high humidity, even if it actually originates over equatorial Africa, South America, or Asia. Antarctic air is similar to Arctic air, and is sometimes designated 'AA'. Air masses are relevant because some may be essentially cloud-free, whereas others often give rise to specific types of cloud. Arctic and polar air may be particularly clear, whereas the humidity in tropical (and equatorial) air usually restricts visibility. Continental air may be very hazy, depending on its source region and subsequent path.

The principal air masses

mA maritime Arctic air
extremely cold and humid

cA continental Arctic air
extremely cold and dry

mP maritime polar air
cold and humid

cP continental polar air
cold and dry

mT maritime tropical air
warm and humid

cT continental tropical air
warm and dry

E equatorial air
hot and humid

▼ A false-colour Meteosat image in the southern spring. The ITCZ is prominent, and a tropical storm lies north of South America.

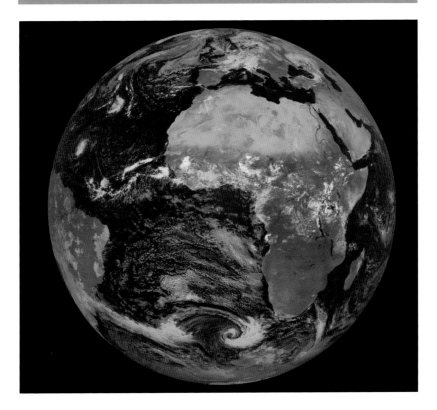

Fronts

The boundaries between air masses with different characteristics are known as fronts. In general, the air masses will differ in temperature and humidity and, as a result, in density. The colder, denser air will tend to undercut the warmer air, lifting it away from the surface. Similarly, if the warm air encounters cooler air, it will tend to rise and slide over the top. It is for this reason that the polar fronts, where cold polar easterlies lie alongside warm tropical westerlies, are unstable. A wave readily develops and this grows until a closed circulation develops around a central low-pressure area. A depression has been born.

▼ This morning image from a polar-orbiting satellite shows the Polar Front off northwestern Europe, and covering Scotland and Ireland. Several distinct waves may be seen, any of which could be an incipient depression. The left-hand side of the image is dark, because the Sun has yet to rise over the central Atlantic.

Depressions (or 'extratropical cyclones' to meteorologists) dominate the weather over temperate regions. On a weather chart, a depression appears as a low-pressure centre surrounded by closed isobars. At the surface, winds flow across the isobars, and in towards the centre. Away from the surface, the winds flow along the isobars. In the northern hemisphere these winds will circulate anticlockwise around the depression centres, and clockwise in the southern hemisphere.

A depression initially has just a cold front and a warm front, with a wedge of warm air (the warm sector) between them. These fronts are often associated with very specific cloud types, and (particularly at the warm front) there is usually a readily detectable succession of different cloud types (cirrus, cirrostratus,

altostratus and nimbostratus) as the front approaches. There are also distinct changes in wind strength and direction, and different patterns of rainfall at the two fronts.

Locating low-pressure centres

There is a simple rule – known as Buys Ballot's Law, named after the Dutch meteorologist who described it – to determine where low pressure lies. If, in the northern hemisphere, you face downwind, low pressure is on your left, and high pressure on the right. The opposite applies in the southern hemisphere. For upper-level winds the centre is more or less directly to your left; for surface winds it is 10–50° farther forward, depending on surface friction (lower over the sea, greater over rugged land).

▼ Polar-Orbiter image of a depression.

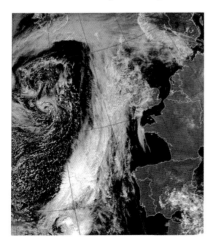

▼ Depression, with an occluded front.

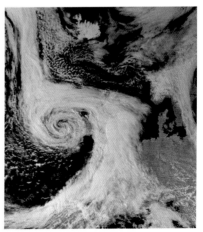

How depressions develop

Cold fronts move faster than warm fronts, and eventually the cold front of a depression begins to overtake the warm front at the tip of the wedge of warm air. It lifts this away from the surface, producing a third type of front, known as an occluded front, where three distinct air masses are in contact, with differing temperatures and humidities. (There are actually two forms of occluded front, but these need not concern us here.) Occluded fronts may give rise to extremely long periods of rainfall or snowfall, and if one stalls over a region, making little forward progress, it often leads to widespread flooding or heavy snow cover.

the satellite images

The images from polar-orbiting satellites may be obtained by anyone with a simple receiver and aerial. The data is transmitted by the satellite as an audio signal that is easily converted into an image by any of several free, widely available programs.

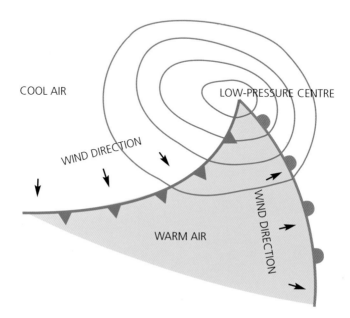

COOL AIR

LOW-PRESSURE CENTRE

WIND DIRECTION

WARM AIR

WIND DIRECTION

Anticyclones (high-pressure centres)

High-pressure areas (known as anticyclones) are regions where air is descending, being compressed and warmed, and are therefore largely free from cloud. (Some exceptions will be mentioned later.) They tend to bring periods of settled weather with little change from day to day. In the northern hemisphere, air circulates around them in a clockwise direction, along the isobars at height, and spiralling outwards from the centre at the surface. Anticyclones typically move much more slowly than depressions, and in fact the latter are often deflected from their paths when they encounter a high-pressure region and are forced to pass

either north or south of the relatively stationary anticyclone. Because high-pressure areas are frequently free from cloud, they tend to produce high temperatures during the day and low temperatures at night. Slow-moving anticyclones, particularly in autumn and winter, may sometimes produce conditions of 'anticyclonic gloom' where stratus and stratocumulus give overcast skies and haze, and pollutants build up beneath an inversion. Such conditions are not particularly inspiring for photography, although at other times, anticyclonic conditions may have clear skies with some small, scattered cumulus clouds or wisps of high cirrus.

▶ In this Polar-Orbiter image, there is a high-pressure area over Europe, which has blocked depressions west of Ireland, and forced others to track north of Scotland.

As mentioned earlier, jet streams tend to develop at breaks in the tropopause; they actually arise where there are sharp temperature contrasts. They are narrow ribbons of fast-moving air, thousands of kilometres long, hundreds of kilometres wide, and just a few kilometres in depth. They snake their way around the globe, and exert a great influence on the development, motion, and decay of pressure systems, particularly depressions. Aircraft often experience clear-air turbulence when they encounter the edges of a jet stream. Although often invisible, at other times jet streams are clearly marked by long trails of cirrus clouds racing across the sky. Satellite images often show them as S-shaped curves above active depressions.

weather watching
jet-stream speeds

The minimum speed of a jet stream is approximately 90–110kph (56–68mph). The highest known speed is 656kph (408mph), recorded above South Uist in the Outer Hebrides, UK, on 11 December 1967.

▼ Jet-stream cirrus.

▲ Fast-moving jet-stream cirrus over Edinburgh, moving at right-angles to the surface wind.

▶ Jet-stream clouds, photographed stretching from Sudan, over the Red Sea to Saudi Arabia. Here the cirrus clouds are arranged in billows at right-angles to the wind direction, but frequently the cirrus streams along the length of the jet.

Chapter 4
Clouds

The most obvious phenomena of the weather, as far as most people are concerned, are clouds, mist and fog. These provide a great variety of attractive and fascinating subjects for weather photographers.

The formation of clouds

Clouds, mist and fog all form when air is cooled below its dewpoint, at which water – which is present in any air, even the driest – condenses into tiny cloud droplets. Cooling may occur either when air rises or when it passes over a cold surface. There are three principal mechanisms by which air rises in the atmosphere: through convection, usually caused by heating of the surface; through being forced to ascend over hills or mountains; through lifting by being undercut by colder air.

When ground is heated by sunlight, parcels of warm air break away from the surface and begin to rise, these are 'thermals'. As they rise, the decrease in pressure with height causes them to expand and cool, eventually reaching a low enough temperature for cloud droplets to form. Cumulus (page 71) and cumulonimbus (pages 72–3) clouds typically form in this way.

Forced ascent over hills or mountains may give rise to a variety of clouds, this depends on prevailing conditions. Frequently, any clouds are layer clouds, such as stratus (see page 74), which shrouds the tops of the hills in mist or fog (which are merely cloud at ground level).

At other times, ascent may trigger the formation of cumulus or cumulonimbus clouds. When conditions are right, spectacular and extremely beautiful wave clouds (page 84) may be generated.

Cloud types

Clouds, like plants and animals, are divided into types (genera), species, and varieties. There are ten primary cloud types, and it helps if you can recognize these, because they give a clue as to what is happening in the atmosphere, and how clouds may change. Naturally, more than one cloud type may be present at any time, and the main type of cloud may change as the cloud cover grows or disperses. Meteorologists recognize 14 different species, nine varieties, three accessory clouds, and six supplementary features, but only a few distinctive forms will be described here. Full details of the various forms, with their names and standard abbreviations, may be found in the works given for further reading, but here is a summary of clouds:

types (genera) basic cloud forms

species shape and structure

varieties transparency

accessory clouds clouds that occur only with certain of the main types

supplementary features highly distinctive forms, most of which occur with more than one cloud type

Clouds are divided into two main families: cumuliform or convective clouds, and stratiform or layer clouds. For our purposes a third category, cirriform (hair-like) or ice-crystal clouds, is also useful.

Cumuliform clouds include: cumulus (see page 71); cumulonimbus (pages 72–3); stratocumulus (page 75); altocumulus (page 78); and cirrocumulus (page 83). (Note the last three occur as layers, and may be regarded as have both cumuliform and stratiform characteristics.)

Stratiform clouds include: stratus (page 74); altostratus (page 79); and nimbostratus (page 80).

Cirriform clouds include: cirrus (page 81); cirrostratus (page 82); and cirrocumulus (page 83).

weather watching
accessory clouds

Accessory clouds are forms that occur only in association with one or more specific cloud types. There are just three types:pannus – ragged fragments of cloud beneath cumulus, cumulonimbus, altostratus or nimbostratus; pileus – smooth 'cap' cloud above rising cumulus or cumulonimbus towers, usually short-lived; velum – thin sheet of cloud created by cumulus congestus or cumulonimbus, and often trailing behind them.

Clouds by height

Clouds are also divided into three groups according to their height. (Cloud heights, incidentally, are normally given in feet, which is the international aviation standard.) Heights are very difficult to estimate, but as far as photography is concerned, some knowledge of approximate heights is useful, because it gives some idea of when particular types are likely to be visible, and how fast they may change.

Low clouds – bases below 6,500ft (approx. 2km/1 mile):

cumulus
stratus
stratocumulus

Medium clouds – bases between 6,500 and 20,000ft (approx. 2–6km/1–4 miles):

altocumulus
altostratus
nimbostratus (this may extend down to the surface)

High clouds – bases at or above 20,000ft (approx. 6km/4 miles):

cirrus
cirrostratus
cirrocumulus

Cumulonimbus may have a huge vertical extent, reaching from near the surface to the tropopause (see pages 72–3).

Low clouds

Cumulus

As thermals rise from a warm surface they eventually reach a height at which cloud droplets begin to form, appearing as ragged scraps of cloud. Initially, these may disperse as they mix with the surrounding air, but when convection becomes stronger, they grow into distinct cumulus clouds. At first these are restricted in height, but if growth continues they become medium cumulus and eventually towering cumulus. In temperate regions in summer, and in equatorial regions at any time of the year, such clouds may give rise to rain, but most rain, snow, and hail occurs in temperate regions when a cumulus congestus develops into cumulonimbus.

Although cumulus clouds go through the cumulus humilis stage as they grow, they are also frequently seen ahead of an advancing warm front. As the warm air moves in aloft, the heating of the ground and the resultant convection are reduced. Rather than rounded tops, the cumulus clouds show characteristically flattened tops.

Cumulus clouds are usually easy to photograph, because they are individual clumps of cloud, usually well separated

▼ Towering cumulus (cumulus congestus) growing rapidly in a cold airstream over the warm sea. (The Fujichrome original had a strong violet cast, which has been removed in this scanned image.)

weather watching
growth of cumulus

cumulus fractus broken cumulus

cumulus humilis flattened cumulus (wider than they are high)

cumulus mediocris medium cumulus (roughly equal width and height)

cumulus congestus towering cumulus (higher than they are wide)

cumulonimbus (see pages 72–3)

from one another, and thus generally well illuminated. Only cumulus fractus may sometimes be rather indistinct, with the visibility of their thin wisps of cloud depending greatly on their position relative to the Sun. The other cumulus forms, however, are much denser and display a wide range of tints from brilliant white to almost black. The light that they reflect is often strongly polarized, and a polarizing filter may reveal striking changes, as shown by the images on page 31.

Often seen with: cumulonimbus

▲ Cumulus fractus and cumulus humilis, photographed at mid-afternoon in summer. The high cirrus, increasing towards the west (right) suggests a warm front will arrive within the next 12 hours.

◄ Cumulus in the early stages of growth (cumulus humilis).

Although cumulonimbus clouds differ from all the other types in that they may extend from the lowest levels to the very top of the troposphere, they may usefully be described here, because they develop from cumulus congestus. A change from the hard, cauliflower-like outline of cumulus congestus towers comes when the top of the cloud begins to freeze (known technically as glaciation). The outline becomes slightly softer, marking the transition to a cumulonimbus (known, somewhat paradoxically, as cumulonimbus calvus – 'calvus' being the Latin for 'bald'). Although this change is not always easy to recognize, it is very significant, because now the cloud will definitely produce rain or snow. The ice crystals fall down through the cloud and, depending on conditions, reach the ground as rain or snow.

As freezing continues at the top of the cloud, the streaks of ice crystals produce a wispy appearance, and the cloud is known as cumulonimbus capillatus. In effect, this is a form of cirrus. If the cloud has reached the tropopause, it spreads out into an anvil shape (incus). Usually the updraughts are so strong that they tend to penetrate a short way through the inversion, before falling back, giving rise to a bump on top of the anvil, known as an overshooting top. Similarly, the strength of the updraughts normally causes the anvil to spread out upwind, as well as downwind.

Individual cumulonimbus cells have a lifetime of about one hour, with

Often seen with: cumulus congestus; cirrus

◄ This giant cumulonimbus cloud, photographed over Florida, is still actively growing, although the tops of some cells have become glaciated, and heavy rain is falling. The tropopause is high here, so the cloud has some way still to climb before reaching the inversion, and spreading out into an anvil shape.

approximately 20 minutes' growth; 20 minutes' maturity with heavy precipitation; and 20 minutes' decay. Longer–lasting storms, which consist of a succession of individual cells or one persistent, giant cell, are discussed later. Photographically, cumulonimbus are such large clouds that parts may be blindingly white, and other portions so dark as to appear nearly black. It is normally best to expose for the brightest portion in overall images, and exclude the bright area if you wish to bring out the structure of the darker, lower regions. Depending on its position relative to the Sun, parts of a cumulonimbus may generally be made to appear more, or less, conspicuous by using a polarizing filter.

▼ A low, winter cumulonimbus cloud that has not reached the tropopause before glaciation has set in, producing a ragged top of cirrus rather than an anvil.

▼ This image from a Space Shuttle of cumulonimbus clouds over Brazil shows the overshooting tops that penetrate a short way into the stratosphere, before falling back and spreading out as cirrus anvils.

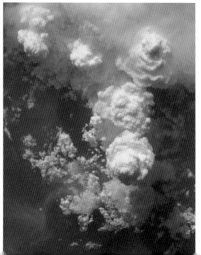

Stratus is a relatively featureless layer of low cloud, which will often hide the tops of tall buildings, hills, or mountains and frequently blocks out the position of the Sun. To anyone within it, it appears like mist or fog (which may be considered as cloud at ground level). Sometimes, the tops of mountains or hills will rise above the layer and hill walkers or mountaineers may find themselves in brilliant sunlight above the cloud.

The base of stratus is rarely completely flat, and generally has various irregularities. Stratus does, however, sometimes exhibit regular undulations on its lower or upper surfaces. Otherwise it is generally rather dull and uninteresting.

Because it is often featureless, it frequently requires the use of manual focusing. It is probably most photogenic when forming or dispersing, when it appears as ragged patches of cloud (stratus fractus). It is then also easy to confuse with cumulus fractus, but occurs only when convection is absent.

Stratus sometimes develop when air flows over a cold surface. Small wisps form, and gradually thicken and combine into a single low layer. Break-up reverses this process and occurs when sunlight becomes strong enough to penetrate the cloud and warm the ground beneath, or when the wind rises and creates turbulence that fragments the layer. Stratus sometimes arises from ground fog that, under the warmth of the Sun, first rises from the surface and then begins to break up into stratus fractus. This frequently happens to valley fog that has formed overnight. Wisps of this cloud may often be seen hovering along the sides of the valley before they finally dissipate.

Often seen with: mist; fog

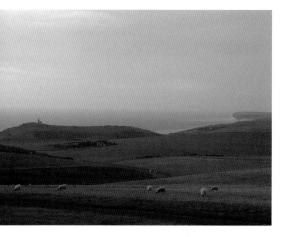

◄ Almost featureless stratus cloud, slightly thinner and lighter over the sea. Belle Tout Lighthouse, where the South Downs meet the sea near Eastbourne, UK.

Stratocumulus

Stratocumulus consists of a sheet of separate masses of cloud, in the form of rounded heaps, flat 'pancakes', or rolls, separated by narrow breaks. It is distinguished from the otherwise similar, higher altocumulus by the fact that the individual elements are always more than 5° across, measured 30° above the horizon. Stratocumulus is a very varied cloud, ranging from white to dark grey, and often forms by the spreading out of cumulus clouds that reach an inversion.

It only rarely produces weak drizzle, and does not give rise to any significant amount of rain. It is the most common cloud over the oceans.

Crepuscular rays (see page 95) are frequently seen shining through the gaps between the cloud elements.

Photographically, stratocumulus is probably at its most pleasing when it consists of evenly spaced billows, which normally form at right angles to the wind direction at cloud height.

Often seen with: cumulus; stratus

▼ A layer of stratocumulus, with sunlight shining through the gaps and appearing as crepuscular rays.

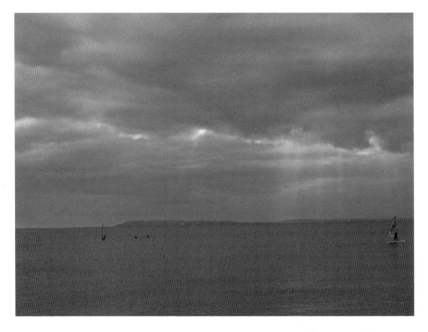

Rare phenomena

Nacreous clouds

Very occasionally, if you happen to be at a fairly high latitude, generally greater than 50° N or S, you may see a display of nacreous clouds – also known as mother-of-pearl clouds – just after sunset or before sunrise. These beautiful wave clouds occur at an altitude of 15–30km (9½–18½ miles) in the lower stratosphere – they are technically known as polar stratospheric clouds – and are visible when you are in darkness, but the cloud layer is still illuminated by the sun. The brilliant colours are actually a form of iridescence (see page 98), caused by diffraction by the tiny ice particles within the clouds, but there is also a colourless (white) variety, created when the cloud particles are much larger, and sometimes visible at the onset of winter.

Nacreous clouds are not particularly difficult to photograph, but the delicate tints may easily be lost through incorrect exposure, so it is always wise to bracket one's shots. The pastel hues are generally most pronounced early in an evening display, and towards dawn in the morning. When the Sun is well below the horizon, only red and orange light reaches the clouds, and the delicate shades are missing.

▼ Part of a brilliant, widespread display of nacreous clouds seen on 16 February 1996, photographed from North Lincolnshire, UK.

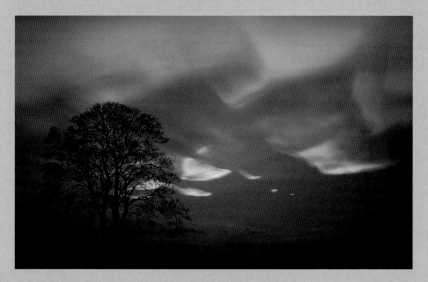

Noctilucent clouds

Although most clouds are invisible at night, unless illuminated by moonlight, certain high clouds are actually visible around midnight. These noctilucent clouds are far higher than any other clouds, because they occur in the mesosphere at altitudes of about 80–85km (50–53 miles). Because of their extreme height, they may be illuminated by sunlight when the observer is in shadow. When present, they are visible for about one month before and after the summer solstice (June 21 in the northern hemisphere, December 23 in the southern) in the direction of the pole for observers at latitudes greater than about 45° N and S.

Noctilucent clouds generally have a characteristic silvery-white colour that is highly distinctive. They may sometimes show a yellowish tint, especially at the beginning and end of a display, and it is common for lower clouds to be silhouetted against them. They are known to consist of ice particles, but the source of the water is unknown. They are actually in the form of a thin sheet of particles that has various undulations, leading to the appearance of billows, bands, and whirls. This apparent structure tends to move westwards during a display, as waves in the high-altitude easterly winds.

Noctilucent clouds are not difficult to photograph, and are captured well on both film (particularly Kodak Ektachrome film) and by digital cameras. Exposures will need to be about 3 seconds at f/2.8 at ISO 400, or the equivalent. Because of the scientific interest in these clouds, it is worth trying to make exposures at precise 15-minute intervals. Triangulation using photographs from other sites enables a lot of information about the structure and motion to be deduced.

▼ A typical display of noctilucent clouds, with billows and whirls, photographed looking north from Edinburgh, UK.

Middle clouds

Altocumulus

Altocumulus is one of the most attractive clouds. Like the lower stratocumulus, it consists of individual masses of cloud, separated by narrow lanes of clear air. Technically, the individual elements are between 1° and 5° across, measured 30° from the horizon. (Anything less than 1° is cirrocumulus, see page 83.) Unlike cirrocumulus, the elements of altocumulus always show distinct shading, and they often occur as regular billows and more complex patterns, often popularly called 'mackerel skies', although this term is also applied to the higher cirrocumulus.

Altocumulus often occurs ahead of a warm front and in the warm sector behind the front. It may also form when cumulus clouds reach an inversion and are prevented from growing any higher.

The gaps between elements may dwindle while the cloud thickens to give an unbroken sheet of altostratus.

Altocumulus mainly consist of water droplets, but ice crystals are sometimes present. This cloud displays optical phenomena such as coronae (see page 97) and iridescence (see page 98). There are numerous different species and varieties, but some of the most striking are wave clouds, altocumulus lenticularis (see page 84). The two distinctive species, altocumulus floccus and altocumulus castellanus are significant, because they indicate instability at that level. If cumulus clouds reach that altitude, they may gain considerable amounts of energy and grow rapidly into cumulonimbus clouds and initiate powerful storms.

Often seen with: altostratus

▼ A layer of altocumulus clouds, with clear gaps between the elements, which thicken to the left.

▼ Altocumulus floccus, gradually merging towards the right and eventually, later in the day, forming an unbroken sheet of altostratus.

Altostratus

Altostratus is a grey or blue-grey layer cloud, without any particularly distinctive features, although it may occasionally appear fibrous. It may occur on its own, particularly through the merger of the elements of a sheet of altocumulus, but often occurs through the thickening of cirrostratus at the approach of a warm front. Initially, the disk of the Sun may be seen as if shining through ground glass, but eventually the altostratus blots it out completely. There may be some precipitation from altostratus, but this rarely reaches the ground. The cloud may consist solely of water droplets, but often contains ice crystals as well. When water droplets are plentiful, the edges of a sheet of altostratus may display coronae (see page 97) around the Sun or Moon, or iridescence (see page 98).

As with other relatively featureless clouds, altostratus may present some problems for autofocus systems, although when striated, the darker streaks will usually provide a lock, as does the disk of the Sun, if this is visible.

At warm and occluded fronts, altostratus generally thickens, its base lowers towards the surface, and it gradually turns into nimbostratus. Patches of altostratus often trail behind fronts and major storm systems.

Often seen with: altocumulus; cirrostratus; nimbostratus

▶ A layer of altostratus thickening ahead of a warm front, which is approaching from the west (bottom right). At this early stage the Sun is still visible, but eventually it will be completely hidden.

Nimbostratus is like stratus in that it is a grey (often dark grey) sheet of cloud that is relatively featureless. Unlike stratus, it produces rain, with is often extremely heavy and persistent. It is also the final member of the sequence of clouds that occurs as a warm front approaches (see page 61). It occasionally (but rarely) forms from altocumulus or stratocumulus or, more frequently, from large cumulonimbus.

Although classed as a medium-height cloud, nimbostratus often extends down to the surface. It is generally very thick and completely obscures the Sun. It gives rise to long periods of rain at fronts, particularly warm and occluded fronts. The rain on occluded fronts may be more or less continuous, but ahead of warm fronts tends to occur as bands roughly parallel to the front, with short dry spells between the bands.

Nimbostratus is not very photogenic, being dark, wet and dispiriting. During breaks in the rain, it may show some structure, with ragged wisps of cloud (known as pannus) drifting beneath it.

Often seen with: altostratus

▼ Nimbostratus over the moorlands of Kinder Scout in the Peak District, UK. There was a momentary break in the heavy rain that persisted for hours on this occluded front.

High clouds

Cirrus

Cirrus clouds are undoubtedly the most photogenic of the high, ice-crystal clouds. The wispy 'mares' tails' are familiar to everyone, but there are several other species and varieties that are just as striking. Hooked cirrus (cirrus uncinus) is extremely distinctive. Dense cirrus (cirrus spissatus) is thick enough to obscure the Sun or Moon, and appears dark grey against the light. Large cirrus spissatus plumes often form as the tops of giant, anvil-shaped cumulonimbus clouds (cumulonimbus incus) and indeed, this portion of the cloud will often persist for hours, or even days, long after the main convective cloud has dissipated. Cirrus clouds are usually fairly distinct (unlike thin cirrostratus, for example) and show a reasonable amount of structure. Although they normally show a moderate amount of contrast with the sky background, they usually benefit from the use of a polarizing filter, which helps to bring out their structure.

Although organized cirrus gradually encroaching from one direction are a sign of an approaching depression, cirrus is also quite common under high-pressure (anticyclonic) conditions. There may be few low or middle clouds but some wisps of higher cirrus, or even quite large masses of tangled cirrus (cirrus intortus).

Often seen with: cirrostratus

▶ A fine display of cirrus, increasing well ahead of an approaching warm front, far away to the left. (The photograph was snatched from a high-speed train travelling at full speed.)

▶ Cirrus clouds gradually covering the sky ahead of an approaching depression, far off to the left of this photograph. The low, cumulus clouds are distinctly flattened (cumulus humilis), which is a sign that warm air is beginning to arrive overhead, and that the reduction in warmth at the surface is reducing the strength of convection.

Cirrostratus frequently goes unnoticed, especially when it is an extremely thin veil of featureless cloud. If the warmth of the Sun begins to drop, even during the middle of the day, and the blue sky seems slightly milky, these are generally signs that a sheet of cirrostratus has started to cover the sky. Yet it is quite common, occurring roughly once in every three days at temperate latitudes. If a halo appears as soon as you hide the Sun, then you can be certain that cirrostratus is present. Although it sometimes remains completely featureless – and may even be dense enough to obscure the Sun to such an extent that haloes are visible without hiding the Sun behind any particular object – it often shows a fibrous or streaky appearance, and is called cirrostratus fibratus. Sometimes the streaks of ice crystals may appear first (when they would be known as cirrus fibratus), and gradually thicken either into a relatively featureless sheet of cirrostratus or into cirrostratus fibratus. Cirrostratus itself is the first of the sequence (cirrostratus, altostratus, nimbostratus) that indicates the approach of a warm front and the accompanying changes of weather.

When it is a relatively featureless layer, there is little that you can do to make it easier to photograph. When it is fibrous, however, a polarizing filter will usually accentuate the contrast between the lighter streaks and the darker sky and make the structure more apparent, although this only applies at a fair distance from the Sun. The main appeal of cirrostratus to photographers is that it normally creates haloes of one form or another – although these disappear as the cloud thickens.

Often seen with: cirrus; cirrostratus

◄ An even layer of thin cirrostratus, giving rise to a 22° halo. Rather unusually, the cirrostratus is thick enough to diffuse the sunlight to such an extent that a good picture has been obtained, even though the Sun itself has not been hidden behind any object.

Cirrocumulus

Cirrocumulus usually consists of a layer, or partial layer, of tiny clumps of cloud, all of which are less than 1° across, measured at an altitude of 30° from the horizon. They are therefore similar to altocumulus, but are higher and thus appear smaller. They are often very thin, have a bluish tint, are without any shading, and are low in contrast. This means that they are frequently difficult to see and photograph. Provided that they are sufficiently far from the Sun, a polarizing filter will greatly improve the contrast. Because cirrocumulus consists of ice crystals, these clouds occasionally refract the sunlight to give parhelia (see page 103) with bright, spectral colours.

Often seen with: cirrostratus

Cirrocumulus lacunosus

The lacunosus cloud variety is officially described by the International Meteorological Organization as having moderately regular breaks or holes and looking like a net. It is, however, rare to see a perfectly regular pattern and the holes are often extremely ragged, or varied in size. Normally the lacunosus variety is associated with altocumulus or cirrocumulus, but it has been recorded with stratocumulus.

▼ An unusually well-defined sheet of cirrocumulus, which is normally much thinner, like the patch at top right. There is some slight suggestion of shading, and the elements are just under 1° across. Any larger, and the sheet would have been classed as altocumulus.

▼ The edge of a sheet of cirrostratus and cirrocumulus lacunosus, which was moving away (towards top left) and gradually decaying.

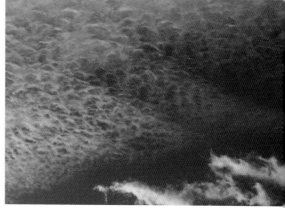

Wave clouds

Wave clouds have a characteristic smooth outline and lens or almond shape (hence 'lenticular clouds'), which normally clearly distinguishes them from other clouds that may be present. They form when air meets an obstacle such as a hill or mountain barrier and is forced to rise over it. This sets up a series of waves above the peaks that extends downwind. When conditions are right, a series of clouds may form in the crests of the waves. These wave clouds (unlike all other clouds) remain stationary in the sky as long as the conditions (wind speed and direction, and humidity) remain constant. The clouds themselves are constantly forming on the upwind side, and dispersing on the downwind side as the air flows through them. (You can sometimes see this happening if you look at them with binoculars.)

Although they are an indication of stable (in other words, non-convective) conditions at their altitude, they are regarded as a species (lenticularis) of stratocumulus, altocumulus, or cirrocumulus, and correspondingly named (for example, altocumulus lenticularis).

There may be a whole series of wave clouds stretching far downwind of the obstacle that is creating them. Occasionally, there is a series of humid layers in the atmosphere, and then several wave clouds form, one above the other. The stack of clouds is known as a 'pile d'assiettes' (French for a 'pile of plates').

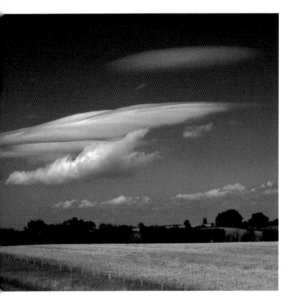

◀ These altocumulus lenticularis clouds were far downwind of the high ground (away to the right) that created them. The photograph was actually captured from a high-speed train, by timing the release of the shutter to coincide with the gap between two of the trackside power-supply pylons.

Jet-stream clouds

As mentioned earlier, jet streams form where there are great temperature contrasts in the upper air, especially near the polar front. Much of the time they flow overhead invisibly, but at times highly characteristic streamers of cirrus stretch across the sky. These normally run parallel to the wind, but on fairly frequent occasions billows develop at right-angles to the wind. Although the clouds are high, it is sometimes possible to see how they are racing across the sky – especially if you view them through binoculars. Because they are ice-crystal clouds they may occasionally produce halo effects (see page 102), and iridescence (see page 98).

▶ Jet-stream cirrus above cumulus clouds, which, however, show no signs of flattening. This suggests that any depression is well away to the west, and warm air has yet to arrive at high levels. Several condensation trails also run across the image.

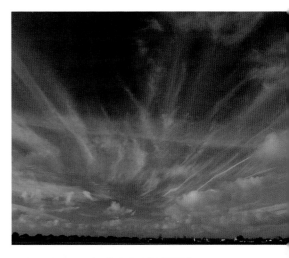

▼ Jet-stream clouds at sunset. The appearance, typical for these clouds, may be compared with the image of high-altitude dust shown on page 93.

Supplementary features

Virga

Virga are trails of precipitation that is falling from clouds but fails to reach the ground. (If it reached the surface, it would be known by the technical term 'praecipitatio'.) These trails may be seen beneath various cloud types, but most notably beneath altocumulus. Cirrus, especially cirrus fibratus and cirrus uncinus, may almost be regarded as consisting of nothing but virga.

Virga are at their most striking when they are backlit (when they naturally appear dark) or when fully illuminated by sunlight so that they stand out in great contrast to the sky. Directly downsun, a polarizer will not make any change in the sky background, but when the clouds are roughly 90° from the Sun, the use of a polarizing filter may make a dramatic difference to their appearance.

▼ Altocumulus clouds and virga. Initially the particles falling from the clouds were ice particles, which fell almost vertically. As these melted, the trails of water droplets started to lag behind the generating head.

Billows

Frequently a layer of cloud is broken up into a regular series of rolls of cloud, known as billows. They occur when there is wind shear present; in other words, when the winds in two adjacent layers of air are either of different speeds, or move in slightly different directions (or both). The billows – technically they are known as the undulatus variety – form at approximately right angles to the wind, but sometimes there are no clear gaps between the rolls, merely a thinner layer of cloud. When a stable layer of cloud is forced to rise, it may produce a relatively rare specific type of billows, known as Kelvin–Helmholtz waves (see facing page). Sometimes billows are mistaken for a form of wave cloud (see page 84), but there is a specific difference: billows move with the wind, wave clouds remain stationary.

▼ This image shows a layer of altocumulus (altocumulus stratiformis), beneath which there is a series of stratocumulus rolls (stratocumulus undulatus).

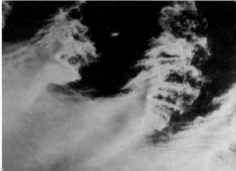

Cloud streets

Frequently, cumulus clouds are observed to form long lines stretching downwind, rather than being more or less randomly scattered over the sky. These rows of cloud are known as cloud streets. Because of perspective they appear to converge in the distance, and are therefore known as cumulus radiatus. Such streets sometimes arise when there are specific locations that favour the creation of thermals. Streets commonly occur downwind of oceanic islands, for example. More frequently they arise when there is a narrow convective layer, capped by an inversion. Air rises through the clouds and subsides in the clear spaces between them, which are generally two or three times the width of the convective layer.

▶ Cumulus clouds arranged in cloud streets (cumulus radiatus). The origin of the streets lies to the right.

Kelvin–Helmholtz waves

Sometimes when there is a large amount of wind shear over a small vertical distance (in other words, when there is a great difference in wind speed with a small difference in height), often at an inversion, short-lived cloud billows form. These often appear similar to breaking waves on the sea but, in fact, the motion of the air within them is very different from the movement of water waves. These billows may last for just a few moments, certainly no more than a few minutes, so you may go years without seeing any examples, and generally you have no time to change lenses or set up a tripod before they have disappeared. They are of great interest to cloud physicists, and ideally should be recorded with a video camera if possible.

▼ A set of three Kelvin–Helmholtz waves. The right-hand one had almost completely decayed by the time this image was taken. The other two waves lasted less than a minute.

Aurorae

Aurorae are not directly related to the weather, but are sometimes seen at night during autumn, winter and spring – at times when noctilucent clouds are absent. For many years it was believed that the two phenomena were mutually exclusive, because auroral displays heat the upper atmosphere, until a Canadian amateur photographed both together.

Aurorae arise when charged particles, which originated from the Sun, are accelerated by the Earth's magnetic field, and crash into the atmosphere in either of the auroral zones over the northern and southern polar areas. The energy excites atoms and molecules in the upper atmosphere, and these emit radiation at very specific frequencies (and hence, colours). The most common colour is a pale green, radiated by oxygen atoms. However, the colours visible to the naked eye strongly depend upon an individual's eyesight, and some people (myself included) are unable to see the red radiation from nitrogen atoms. Luckily, photography is able to capture most of the colours, although some of the purple-violet shades do not register well on film.

There are various different forms that the aurora may take, but these cannot be described in detail here. They range from faint patches of light to vast curtains (that are known as bands) that appear to wave across the sky in a non-existent wind.

Photography is relatively simple, but may require some experimentation and bracketing of shots because of the very different brightness of different displays. A tripod is essential. Ratings of ISO 200 and 400 (or equivalent) are suitable, together with exposures of a few seconds, and wide apertures. For the fastest motions, sometimes seen with auroral bands and rayed structures, you may need to drop exposure times to less than one second, otherwise blurring of individual striations (known as rays) may occur. Digital cameras are, of course, ideal for this work, because you can examine your results immediately and make the appropriate changes. As with noctilucent clouds, exposures made at 0, 15, 30, and 45 minutes after the hour may be used to derive heights and distances of displays when they are combined with other images obtained from elsewhere.

▶ An auroral form known as a quiet, homogeneous arc, often the earliest type to be seen during a display. This was shot looking north from Edinburgh, UK.

▶ Bright red auroral rays, photographed looking north over the city of Chichester, West Sussex, UK.

Chapter 5
Sky colours and optical phenomena

Aside from clouds, there are many other phenomena that make the sky such a fascinating place to look for potential photographs; and as well as these phenomena there is the colour of the sky itself, which can take on an intriguing array of hues.

The colour of the sky

Everyone knows that the sky is blue. This colour actually arises because the molecules in the air scatter violet and blue light in all directions, but have little effect on light of other wavelengths – most notably on yellow and red tints. Human eyes are unable to pick up the violet colour, so we perceive the sky as blue. But the depth of this colour depends greatly on the amount of water vapour and haze particles in the air. In the mountains, where there is little water vapour, the sky takes on a deep blue tint, but at low level this colour is diluted to a paler tint by the white light scattered by water vapour. It is primarily this scattering that produces aerial perspective, where more distant objects take on paler tints.

◄ Although we are rarely aware of it, we unconsciously use aerial perspective, where more distant objects are paler and have an increasing blue tint, to judge distance.

Sunset colours

At sunrise and sunset, the sky in a roughly semicircular area above the Sun (known as the twilight arch) goes through a series of colours. At sunset, for example, initially the sky above the Sun's position is pale yellow, with bluish-white tints above that. Later on, the twilight arch will turn orange at the horizon, with yellow slightly higher in the sky, and a salmon-pink tint higher still. This colour slowly sinks towards the horizon, while the sky above darkens from bluish-grey to a slightly purple tint and eventually deep blue. Often greenish tints are visible where the yellow tint merges into the blue of the sky, and the last colours on the horizon are often a greenish-yellow tint. At sunrise, the sequence will be reversed, of course.

Even on clear days, there is often a brownish band of haze along the horizon. This is particularly noticeable at sunset, because the haze particles (arising from various sources, including human activity) tend to build up during the day, but disperse at night. The layer of haze is normally less prominent at dawn.

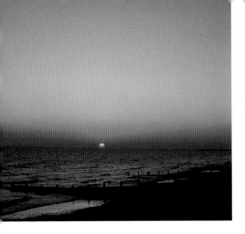

▲ Sunset over the Solent, UK, with a distinct, brownish haze layer that had built up during the day.

▲ An 'ordinary' twilight arch at sunset, with yellow, salmon-pink, and bluish tints.

High-altitude dust

Occasionally, the sky takes on a very different appearance at sunset (or sunrise). It shows a distinct orange tint, and there are often visible streaks across the sky. But these streaks are unlike cirrus clouds, even unlike those seen in jet streams, because instead of radiating from a distant point on the horizon, they run parallel to it. What you are seeing is actually a thin layer of high-altitude dust, ejected into the upper atmosphere by a volcanic eruption. The dust layer is normally very thin, and slight undulations in the surface give the appearance of streaks across the sky (just as with the appearance of structure in noctilucent clouds). Sometimes the patches of dust are relatively small, and nothing will be seen on subsequent nights, but on other occasions, after major eruptions, these sunset displays may be seen for several nights.

▼ High-altitude dust streaks caused by a volcanic eruption, still illuminated well after the Sun had set for the observer on the ground.

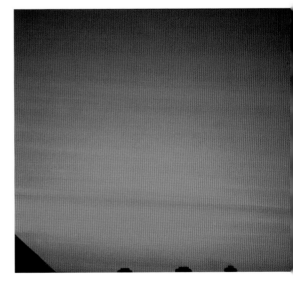

weather watching
the Purple Light

On very rare occasions, an even more striking effect is seen. This is the Purple Light, when the whole of the twilight arch takes on a vibrant purple shade. Again, this is related to volcanic activity, but this time it is primarily sulphur compounds that have been ejected into the upper atmosphere, where they react with water to create droplets of sulphuric acid. These scatter red light from the Sun, which mixes with the normal, blue, scattered light to give the intense purple tint. The colour is quite unmistakable when seen by the eye. Unfortunately, it is one of those colours that cannot be captured properly by either positive or negative film, because of the limitations of the colour response of the three layers of the emulsion. As with certain flowers, its true colour cannot be captured, and any photograph is likely to disappoint. But what about digital images? At present, we cannot say. Since digital cameras became common, there has not been a major volcanic eruption, comparable with the eruption of Mount Pinatubo in 1991, that would be powerful enough to inject large amounts of sulphur dioxide into the upper stratosphere. If there is an eruption, and you manage to capture that elusive Purple Light in all its glory with your digital camera, please let me know – and send me a copy!

◄ This image shows only a faint hint of the vibrant purple shade that was clearly visible to the eye. Even so, it is clearly different from the normal tints seen in the twilight arch.

Crepuscular rays

The term 'crepuscular rays' is a slightly formal name for a very prosaic phenomenon: bands of shadow or rays of light that appear to radiate from a distant point on the horizon. Although 'crepuscular' suggests they are visible only at twilight, they may be seen at any time. There are actually three distinct forms, although all have a similar origin:

• bands of shadow that radiate from below the horizon at sunset or sunrise (the true crepuscular rays);

• shafts of light or bands of shadow that appear to radiate from the edge of a cloud;

• shafts of light that penetrate through gaps in a layer of cloud.

The rays seen at twilight are the shadows of distant clouds or mountain peaks cast on the atmosphere itself or, occasionally, on the underside of a layer of cloud. The shadows cast on the atmosphere are most distinct when the atmosphere is humid or hazy. When the Sun is low, the rays tend to appear pink, and the shadows have a greenish tint. Sometimes rays may be observed right across the sky, converging on the antisolar point. They are then known as 'anticrepuscular rays'.

It is common to see shafts of light or dark shadows apparently radiated by the edges of clouds, but in fact caused by the Sun being obscured by the clouds. Frequently the clouds themselves are outlined in light, and some have suggested that this is the origin of the phrase 'Every cloud has a silver lining'.

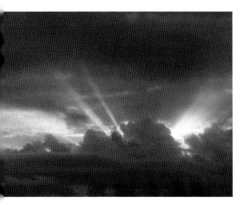

▲ Bright crepuscular rays cast between the towers of a fairly substantial line of cumulus and cumulonimbus clouds.

▲ Here, two bands of shadow are being cast by lower clouds onto the base of a higher cloud layer.

In the third type, rays of light pierce through gaps between clouds. This appearance is most commonly seen with stratocumulus clouds, and is sometimes known as 'the Sun drawing water'. Occasionally, these rays, when seen at a distance, are mistaken for shafts of rain. However, if you have correctly identified the cloud as stratocumulus, this cannot be true, because stratocumulus rarely produce more than a light drizzle.

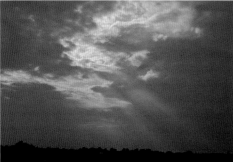

◀ True crepuscular rays cast by the Sun, which is below the horizon. Because of the colour contrasts, the dark shadows often appear to have a greenish tinge.

◀ Crepuscular rays are commonly seen radiating from the gaps between elements of stratocumulus.

Shadow of the earth

▲ The shadow of the Earth, rising in the east, seen over the Aletsch Glacier in the Alps.

At sunset, as the Sun sinks in the west, a steel-grey band slowly rises in the east. This is the shadow of the Earth, cast upon the atmosphere. The upper border is usually red, and this is known as the counterglow. As the Sun sinks beneath the horizon, the shadow rises higher and darkens, until eventually it merges with the dark blue sky overhead. The coloration of the counterglow is subtle, so bracket your exposures to ensure that you capture it correctly – particularly if photographing it from a mountain, because the dark blue sky tends to lessen the contrast of the shadow.

Coronae

A corona is a series of coloured rings that appears around the Sun or Moon, when its light shines through a thin layer of water-droplet cloud. Because the Sun is so bright, people tend to notice lunar coronae more frequently, but if you detect thin cloud during the day, and hide the Sun, you may well see a corona. Generally, of course, to take a photograph, the Sun needs to be hidden behind a solid object. With the Moon, this is not always necessary. There are two parts to a corona: an inner region, the aureole, with a bluish-white inside and a red-brown border, and one or more outer rings showing spectral colours, with violet inside and red outside. Coronae are one of various diffraction phenomena that occur. This means that cloud particles neither reflect nor refract the light, but deflect the light around them. As with iridescence (see page 98), the colours depend on the size of the particles involved.

Glories

A glory is related to coronae, in that it also arises through diffraction, but in this case it is visible as a series of one or more coloured rings around the antisolar point. As with coronae, violet appears on the inside of each ring, and red outside. It is most often seen by hill-walkers in a bank of mist or fog, or looking down onto a layer of cloud. Each person sees only the rings around their own head, hence 'glory'. Now it is more commonly seen around the shadow of a plane.

Photographing coronae is not particularly difficult, although care needs to be taken to expose correctly for the subtle tints. The inner aureole is also usually fairly small, so a telephoto lens may be needed.

▼ A lunar corona. Although the Moon itself is hidden, it was nearly full, and therefore provided sufficient illumination to see part of the second, spectral-coloured ring.

▼ A glory surrounding the shadow of the photographer's plane.

Iridescence is extremely common, but is rarely noticed. It generally appears as narrow bands of colour at the edges of thin clouds. It is most pronounced within about 35° of the Sun, and this is, of course, why it is normally unnoticed. As with coronae and haloes, the Sun itself should be hidden, and then delicate pastel tints become visible in thin wisps of cloud. The clouds may be ice-crystal or water-droplet clouds.

Iridescence is, in fact, the cause of the beautiful colours seen in nacreous clouds (see page 76). The colours displayed are closely dependent on the size of the cloud particles: where the colour is the same, the particle size is essentially the same. Quite frequently, bands of colour run along the edges of clouds, indicating where all the particles have the same size.

kit
bracketing

As with all delicate tints, it is advisable to bracket exposures to obtain satisfactory images.

◄ Delicate iridescence in patches of cirrocumulus. This image illustrates how iridescence changes quickly over a short distance. The cloud at bottom left is too close to the Sun for the effect to be clearly visible, unlike the cloud at centre left.

▼ Fairly strong iridescence on the edge of a sheet of altostratus.

Sunset cloud colours

When most people speak of a beautiful sunset, they are generally referring to clouds illuminated by the setting Sun. They are also very often disappointed when they try to take a photograph, because the colours are nothing like those that they saw. With film cameras this is often the result of overexposure, which produces a pale Sun and clouds. With digital cameras the problem usually arises because of the automatic white-balance function, which senses that the colour temperature is lower than at midday, and adjusts the colour balance accordingly. It is a case here of getting to know your camera, and finding out the best way of compensating. With film cameras, set a negative exposure compensation or take manual control of aperture and shutter speed. (You can take the automatic exposure values as a guide.) With digital cameras, you can override the automatic white-balance system, by switching it to a preset that is suitable for daylight, perhaps. This will ensure that the tones are rendered as you see them, instead of being neutralized. Remember that shooting in RAW format will enable you to apply alterations later on computer.

When taking sunset pictures, it pays to be ready. If there is any suggestion that the sunset may be particularly striking – be prepared. The illumination can change so rapidly that clouds may be brilliantly coloured at one moment, but then swiftly lose their colour and turn a dull grey the next.

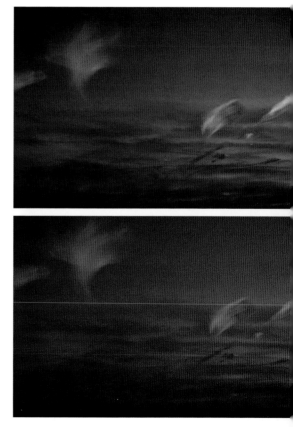

▶ A difference of just a few minutes may bring a dramatic change in the appearance of the sky. These two images, taken about seven minutes apart, illustrate how the lighting around sunset and sunrise may alter substantially. The 'goldfish' clouds are actually remnants of contrails that have broken into individual segments.

Condensation trails

Condensation trails from aircraft ('contrails' to meteorologists) may seem a slighly unusual subject for weather photography, but in fact they are both meteorologically significant, and offer photographic opportunities.

Contrails arise when aircraft inject a significant amount of water vapour from their engines into the atmosphere. They may consist of water droplets or may freeze into ice crystals. When the air at height is very dry, contrails dissipate rapidly, but if they persist and spread across the sky, it is usually a sign of increasing humidity at height and indicates that a warm front is approaching.

As with cirrus clouds, the ice crystals in contrails may give rise to brilliantly coloured parhelia (see page 103), which are often more striking than those seen in cirrostratus. Quite frequently, persistent contrails develop a series of virga (see page 86) and may stretch across the sky.

◄ Persistent condensation trails (which have normally become glaciated – in other words, frozen) very often assume strange, convoluted shapes.

▼ Persistent contrails, one showing a series of generating heads where ice crystals are forming, and another with the spectral colours of a parhelion at the same altitude as the Sun.

Distrails

To accompany contrails, we also have distrails: dissipation trails. Surprisingly frequently, when an aircraft flies through a thin layer of cloud it will disperse the cloud, leaving a clear lane behind it. This occurs partly because of the warmth of the exhaust from the engines, which may also provide a source for suitable condensation or freezing nuclei, but primarily because the plane mixes drier air from above and below the cloud into the layer. Frequently a line of cirrus may be seen, hanging below the distrail.

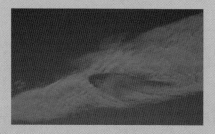

▲ The passage of an aircraft through this layer of thin altocumulus has caused the water droplets to freeze and fall out of the layer, leaving a distrail and an accompanying line of cirrus.

▶ Although resembling fallstreak holes that sometimes occur in altocumulus, this particular opening probably did not originate in this manner. There are no signs of lower fallstreaks, and faint outlines of cloud cells are visible inside the gap in the cloud.

Fallstreak holes

Sometimes aircraft will produce a dissipation trail in cloud, which then develops into a line of cirriform cloud, consisting of thousands of individual virga. A somewhat similar situation may occur spontaneously in altocumulus or cirrocumulus. Large holes (fallstreak holes) develop within them. Sometimes these holes may be completely clear of any form of cloud, but usually there are indications of cirrus streaks or virga beneath them. This gives us a clue as to what has happened. Altocumulus and cirrocumulus clouds are often supercooled – despite being below 0°C, the water droplets have not frozen, because there is a lack of the essential particles to act as freezing nuclei. But once a particle does freeze, it often shattters into fragments, which then act as nuclei for further crystals to form. There is a sudden chain reaction, with freezing spreading out from the initial centre. The ice crystals then fall out of the cloud, leaving a hole.

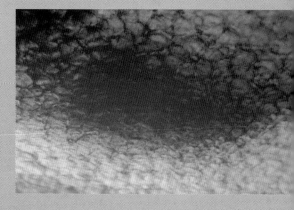

Rainbows and fogbows

Rainbows arise when sunlight falling on raindrops is reflected back towards the observer. If there is a single reflection within each raindrop, it creates a primary bow, with a radius of approximately 42° about the antisolar point. Its spectral colours run from red on the outside to violet on the inside. Two reflections within each droplet produce a fainter secondary bow, with a radius of approximately 51°,

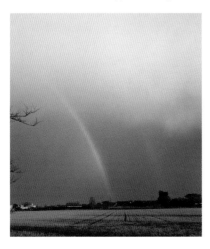

with a reversed spectrum of colours. Between the two bows is a dark area, known as Alexander's Dark Band, where light is reflected away from the observer.

Rainbows are not hard to shoot, but care should be taken that the use of a polarizer doesn't cause sections of a bow to disappear. When the Sun is low most of their colours disappear, and rainbows that are just red may be seen.

Quite frequently, pastel-coloured arcs are seen within the primary bow. These 'supernumerary' bows are caused by interference between rays that have taken slightly different paths to reach the observer. On rare occasions, if there is a sheet of calm water or other reflecting surface behind the observer, additional, larger bows may be produced, rising from the ground at the ends of the primary and secondary bows. Usually only small sections of these bows are visible.

Fogbows have the same size as primary rainbows but occur when the water droplets are very small. Such bows are mainly white, with an occasional hint of red outside and violet inside.

◀ A bright primary rainbow with a faint secondary bow, taken towards sunset. The shadows on the stubble field indicate the direction of the Sun.

◀ A well-defined double rainbow, photographed at Boambee, New South Wales, Australia. The faint arcs visible within the primary bow are the supernumerary bows.

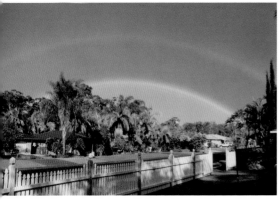

Halo phenomena

A number of optical phenomena are produced when sunlight is refracted or reflected by ice crystals in the atmosphere. There are far too many variations for all to be described in detail here. Here are some of the most significant forms:

22° halo A circular ring centred on the Sun, usually white, but sometimes with red inner edge.

46° halo A circular ring centred on the Sun, fainter than 22° halo.

Parhelion (mock Sun) A bright spot on or just outside a 22° halo, sometimes coloured and often with a white 'tail' pointing away from the Sun.

Parhelic circle A white arc, parallel to the horizon at the altitude of the Sun.

Circumzenithal arc A coloured arc centred on the zenith, up to 108° long on the side nearest to the Sun.

Circumhorizontal arc A coloured arc, parallel to the horizon, beneath the position of the 46° halo.

Sun pillar A vertical pillar through the position of the Sun, white, yellow, orange or red, depending on the Sun's altitude.

Subsun A white ellipse, well below the horizon, seen from ground level, and thus seen only from an aircraft or mountain.

The 22° and 46° haloes

As discussed earlier (see page 24), a wideangle lens is required to capture the two circular haloes most frequently seen in cirrostratus cloud. They are not hard to photograph, although attention should be given to the exposure, particularly if the Sun (or Moon) is sufficiently dimmed by the cloud not to require being hidden.

Parhelia

It is quite common to see a parhelion (mock Sun) on its own in a patch of cirrus or other ice-crystal cloud. Unless the clouds themselves are particularly photogenic, the use of a telephoto lens is frequently worthwhile, because it will bring out the details of the structure of the cloud and the parhelion itself.

▶ A bright parhelion, appearing on its own, with no trace of a circular halo. Such parhelia often appear as brightly coloured phenomena in isolated patches of cirrus cloud.

Circumzenithal arc

The spectral colours seen in circumzenithal arcs are generally brighter than those found in other halo phenomena. If the 46° halo is present, the circumzenithal arc may touch it, or lie a short distance away, depending on the exact altitude of the Sun. The only brighter halo phenomenon is the circumhorizontal arc, which runs parallel to the horizon and may sometimes exhibit spectacular spectral colours. This arc, however, cannot be seen unless the Sun's elevation exceeds 58°, so it is readily visible only at low latitudes.

Sun pillar

Sun pillars are quite common but often overlooked. They arise when sunlight is reflected from the surfaces of plate-like ice crystals floating in the atmosphere. Sun pillars are actually shaped like extremely elongated figures-of-eight, but normally appear to be more or less parallel-sided streaks of light. Very occasionally, a bright crepuscular ray (see page 95) may fall on the underside of layer clouds and resemble a sun pillar, but usually the difference in cloud type reveals what has happened. Subsuns are actually a specific form of sun pillar that appears well below the horizon.

▼ A circumzenithal arc in cirrus cloud. Although far from the full extent that is sometimes visible, this example exhibits the typically pure spectral colours for which this arc is notable.

▼ A sun pillar in thin, and unusually patterned, cirrus clouds.

weather watching
unusual phenomena

There isn't space to discuss every unusual phenomenon here – although more can be found in the works given under 'Further reading' – but here are a few of the most common:

Alpine glow Orange, pink or red glow to mountain-tops opposite the Sun.

Brocken spectre An apparently magnified shadow of the observer on mist or fog.

Dewbow A coloured 'rainbow' on dew-covered grass.

Green flash The last portion of Sun at sunset, a brilliant green.

Heiligenschein A halo of light around a shadow of the observer's head on grass or a similar surface.

Mountain shadow Triangular shadow of mountain peak at sunrise or sunset.

Upper and lower halo arcs of contact V-shaped arcs touching the top or bottom of haloes.

Superior and inferior mirages Images of distant objects seen above hot or cold surfaces.

Some phenomena are so rare that any observations are of scientific interest. These include: aurorae; unusual electrical phenomena; unusual halo arcs; Kelvin–Helmholtz waves; nacreous clouds; and noctilucent clouds. Record as much detail as possible (date, time, place and so on) and note the focal length. Details should be reported to one of the organizations listed on page 142.

▶ This shot shows a white arc, approximately 32° in radius, lying between the 22° and 46° haloes. A circumzenithal arc is also visible (at the top of the frame), as is a U-shaped upper arc of contact with the 22° halo. I know of no other photograph of this 32° halo, and it is not listed as a known arc.

Chapter 6
Photographing weather

Although weather images have much in common with general landscape photography, there are plenty of useful tricks that are worth learning.

Composition

The general guidelines for successful composition of weather-related photographs are similar to those that apply to any landscape images, but there are some specific pitfalls, especially when photographing clouds or optical phenomena.

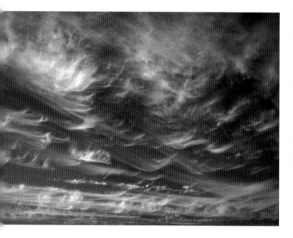

▲ The nature of these hooked cirrus clouds (cirrus uncinus) makes the orientation quite obvious. The image might have been improved if it had been possible to include some foreground objects. Unfortunately this was not possible, because the photograph was taken from the top of a hill, without a wideangle lens. A portrait-format image would have lost all impact. Now, with digital images and stitching software, it would be simple to combine images to include the foreground, especially as the clouds contain detail that would assist a stitching program.

Sometimes the area that you want to include contains nothing but cloud or sky. Such images, devoid of reference points, may sometimes be impossible to orientate and difficult to interpret. Sometimes there is simply no sense of scale.

Landscape or portrait

There is a natural tendency to take cloud photographs with a landscape format, but it is always worth trying a portrait format, which often reveals a different aspect of the subject. It may enable you to include some foreground objects or, for instance, distant hills or the sea horizon, which may help to provide a far more satisfactory image. Using a shorter focal length – whether in landscape or portrait mode – may also enable you to include something that gives depth to the overall image, even though the principal object of interest may occupy a smaller area of the final frame. Some striking images may be able to stand on their own, but generally the inclusion of some foreground objects will improve any weather image. In photographs of unusual or rare phenomena, a sense of scale is extremely useful, and in such cases a record of the focal length used is exceptionally valuable.

Changes of viewpoint

Sometimes there is such a variation in the clouds and sky that even a slight change in camera direction or viewpoint may result in completely different images. Under such circumstances, provided there is not a great variation in the illumination, panoramic images may be particularly interesting and pleasing.

Changes in the clouds

It is also worth bearing in mind that clouds may change rapidly, both individually and over the sky as a whole. A few minutes may bring a dramatic change in appearance, and this is particularly the case at sunrise and sunset, when both the direction of the illumination and its colour may show striking alterations (see page 92). At such times it is worth being patient, and spending a few minutes watching the changes that take place in the sky. If you happen to be suitably placed, cumulonimbus clouds, in particular, sometimes show striking changes in just a short period.

Slower changes occur over a day, and an interesting sequence may sometimes be obtained by setting a camera on a tripod pointing at an interesting skyline, and taking a series of photographs at intervals throughout the day, ideally from dawn to dusk. Such a record often shows a surprising variety of different aspects of the sky.

A viewfinder grid is often of great assistance when composing a shot. It

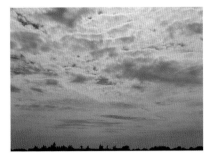
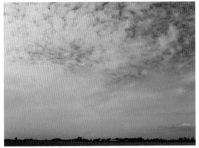

▲ Two images taken within moments of one another – but one might almost think that they had been obtained on different days. In fact, they show parts of the same sheet of altocumulus, the one taken towards the Sun, looking generally south, and the other towards the west. The latter also shows a few distant cumulus clouds.

will not only help to ensure that a sea horizon (for example) is truly horizontal, but may also be used to align the flat bases of cumulus clouds or the level tops of cumulonimbus anvils. It is particularly useful when composing the individual frames that are to make up a panoramic image.

Stereoscopic photography

Stereoscopic photography is greatly neglected, yet it is ideal when photographing clouds (in particular) and other atmospheric effects. It is always extremely difficult to appreciate the relationship between different layers of cloud or of clouds at different distances, but viewing them stereoscopically makes the details immediately apparent.

There seems to be a misconception that stereo photography is difficult. All it requires is a little ingenuity in obtaining two images that may be viewed as a stereo pair. Here are some specific recommendations relating to the separation of the camera locations and the distance of the subject:

d = eye or camera separation
D = distance to object being photographed

$5 < D/d < 50$ for good stereo effects

$D/d = 5$ to 15 for the closest object in the photograph

$30 < D/d < 50$ recommended separation

There appears to be an element of variation from one person to the next in this, however, because in practice, I have found that I can experience stereo effects with very small offsets between the camera locations.

But first we need to make sure that we can fuse a pair of images successfully. There are two basic methods that do not require any equipment (in other words, the use of a special stereo viewer): the 'crossed-eyes' and the 'relaxed-eyes' methods. The latter (used for the 'Magic Eye' images popular some years ago) is not described here, because it is best suited to smaller images than the photographs that we want to examine.

With the two images in front of you, evenly illuminated, you simply cross your eyes – surely everyone has done this as a child? – which will produce four images. By controlling the amount by which your eyes are crossed, the two

◀▼ A stereo pair, obtained by taking one image, stepping sideways by about three paces, and taking the second. In theory this should be inadequate to give a stereo pair, because all the objects are at distances greater than 150m (in other words D/d > 50).

central images (one from each eye) are superimposed. The actual fields of view will differ slightly, but your attention should be on the centre of the field, and you should ignore the edges of the frame. Concentrating on some specific feature that is visible in both of the images, bring them into coincidence. The images will suddenly snap into a 3D image. (Some people find that it helps to shake the head very, very slightly from side to side, which causes the images to move in and out relative to one another. Similarly, the images may appear tilted with reference to one another, and this may be corrected by tilting the head slightly.) Once the

images have 'locked' you should find that you are able to look at any part of the image without losing the stereo effect.

The images that are shown here have dots above them to help with fusion and serve as reference points. If you bring the dots into coincidence, you should find that the images beneath them fuse easily.

Images may be obtained in three different ways and (for me) the simplest is the best: taking one exposure, then moving sideways swiftly and taking the second shot. Any slight inconsistency in the area covered at the top or bottom of the frame may be adjusted by

cropping one image at the bottom and the other at the top, so that both have the same height. (With practice at superimposing images, even this refinement may be omitted.) An extension of this method is to use the motion of a vehicle to provide two viewpoints.

Alternatively, two cameras may be used, and the exposures made simultaneously. The third method uses a fixed camera (on a tripod), and allows the clouds to move across the frame. In theory, the change should be about 5°. This does not give a true stereo pair, but provided the clouds are not evolving rapidly, does normally prove satisfactory.

◄▼ Another stereo pair made by moving sideways between exposures.

Combined and panoramic

Digital photography and the advent of suitable computer programs have meant that it is now relatively easy to combine two or more images to give wideangle or panoramic pictures. Transparencies and negative images may also be scanned and subsequently combined. Many weather subjects – particularly clouds – are extremely suitable for this sort of treatment and you can produce striking images. There are, however, some potential pitfalls.

'Pseudo-panoramic' settings

It may be noted, incidentally, that the so-called 'panoramic' setting available on APS cameras merely achieves its effect by masking the top and bottom of the frame, which is then enlarged to give a long, narrow, 'pseudo-panoramic' image with a correspondingly reduced resolution. A number of digital cameras have a panorama setting, where the camera provides assistance with the framing and overlap between the images, rather than relying on stitching together images with arbitrary overlaps in a computer at a later stage. This method is reasonably successful for weather images, but is not as versatile as later processing.

A wideangle substitute

Combining two or three images is a particularly useful technique when a wideangle lens is not available. If no tripod is used, two landscape-format or three portrait-format images – sometimes more – may be combined successfully if care is taken in the framing of the individual photographs. Don't forget that images may be stacked vertically, as well as horizontally.

◀ This rather prosaic picture consists of two images, stacked vertically. The uppermost branches of the dead tree on the left were deliberately included in both frames to serve as reference points for the stitching program (Photoshop Elements).

True panoramas

There are some essential points for all panoramic shots, but which are particularly important for weather images. These may be divided into the practical aspects of setting up the shots, and those that relate to the actual composition. Points to bear in mind when taking the separate images are:

• Use a tripod with a spirit level, if possible, to ensure that the camera remains level when panned. (Ideally, the lens–camera combination should rotate around what is known as the rear nodal point of the lens, but this requires a specialist tripod head. With most weather images, located close to, or at, infinity, this is less important than with architectural and other subjects that are relatively close to the camera.)

• If no tripod is available, try to steady yourself and the camera against a tree, rock, wall, or any other suitable object.

• If hand-holding the camera, remain in the same position. Even the slightest difference in camera-to-subject distance may produce a distorted perspective.

• Pay particular attention to alignment if taking portrait-format images, because many tripod heads – particularly the ball-and-socket type – have no method of ensuring that the camera is held truly vertical. Use a spirit level and a viewfinder grid to assist in both horizontal and vertical alignment.

• Wideangle lenses used in landscape format often show converging verticals at the edges of the frame. These can make it impossible to match adjacent frames. Use of a wideangle lens in portrait format will minimize the effect, but better results will normally be obtained with a standard lens.

• If possible, use a zoom lens in the middle of its range, rather than at either extreme, because it will then give its best performance and least distortion. Similarly, try to use a reasonably small aperture (say, f/8 or f/11), which will give the most even illumination.

• Lock the exposure so that it is identical for each individual frame. If there is considerable variation in (say) the amount of sky and foreground from one end of the intended panorama to the other, it would be sensible to determine the exposure for an 'average' section and use this setting for all of the frames.

• Take the individual pictures with as little delay as possible. It is, however, a good idea to take two frames of each section. Sometimes one will prove a slightly better match with the neighbouring frame than the other exposure.

• Remove any polarizing filter from the lens. The polarization of the sky is unlikely to be constant from one end of the panorama to the other, and this would lead to a difference in exposure.

When it comes to the actual composition, some points to bear in mind are:

• When using cameras without a specific panoramic function, ensure that there is a reasonable overlap (20–25%) between images – a viewfinder grid is invaluable. Resist the temptation of very large overlaps, because these can cause problems when the images are stitched together. If there is an important part of the image, such as a distinctive cloud, try to ensure that this falls in the centre of a frame, rather than across a join.

• Try to avoid including any nearby (or even middle-distance) objects, because these can lead to distorted perspective when individual frames are combined.

• Remember that unless they run across the centre of each frame, straight lines, such as the horizon, may appear curved when the images are combined. If the horizon does appear, and you wish it to appear straight, then take portrait-format individual frames, centred on the horizon, and crop the bottom of the final image.

• Finally, take care to exclude any moving object, not only because it may appear in more than one of the individual images, but also because a

▲ Three hand-held landscape-format pictures have been combined here. (The opportunity was too good to miss, even though no tripod was available.) The exposure was locked, but no processing has been carried out in the computer. An adjustment to the brightness of the left-hand or central images would eliminate the slight difference in shading of the sky.

prominent object, such as a moving vehicle, can easily prevent accurate stitching of the images.

All this may make it sound extremely difficult to achieve good combined or panoramic images, but this is not the case. Even hand-held images usually provide excellent results. Of these points, locking the exposure and ensuring that the camera is level are probably the most important when photographing meteorological subjects.

By their nature, images of clouds and optical phenomena are harder to combine than ordinary landscapes or townscapes. Stitching programs operate by matching features, particularly distinct edges, between frames. Unfortunately, many weather images are relatively diffuse, so accurate

stitching may be difficult or impossible to obtain. Images of (say) sharp-edged cumulus clouds against blue sky may be perfectly satisfactory, but rainbows and halo arcs are less likely to be suitable. Such subjects are best photographed on a single frame with an appropriate wideangle lens. But there is one trick that you can try in such cases when combining a pair of images. See if you can include some object with a distinct outline, such as a tree, in both shots. This will provide a fixed reference for the stitching program, and the object can often be removed afterwards, if necessary, by cropping the image.

Just because it is now relatively easy to create panoramic images, this does not mean that they are necessarily always desirable. The photograph of some jet-stream clouds illustrates two of the problems. These clouds were extremely visually striking because of their long, straight streaks running right across the sky. Trying to create a panoramic image, however, causes the streaks to appear curved, losing their visual impact. In addition, the joins between the individual frames have become apparent because of the abrupt changes in curvature. The only way to obtain an even curvature would be to use one of the old panoramic cameras with which the lens rotates about a vertical axis to sweep a linear image across the film.

In such cases, a photograph with a wideangle lens in which the cloud streaks appear straight (and thus reproduce the visual impression) may result in just as striking an image, even though it covers a smaller area of sky.

▼ The panoramic image of jet-stream clouds, constructed of five individual frames, discussed in the text. In this case, the Olympus Camedia Master Pro program gave the best result, closely followed by Ulead 360.

The view from an aircraft not only makes it much easier to determine the relative heights of different sorts of cloud – something that is notoriously difficult from the ground – but also makes their individual structure, such as the various cells in cumulonimbus clouds, much clearer to understand.

Flights often cross weather systems and fronts, which offers the chance to photograph different types of clouds and weather conditions. Check before flying to see if any lie on your route. High-pressure systems may be largely clear of clouds, or else hide the ground beneath a relatively featureless blanket of cloud (in the conditions known as 'anticyclonic gloom'). Crossing a low-pressure system may bring a wide variety of cloud types, and some of the most interesting are visible when there is extensive convection (and the related turbulence gives you a bumpy flight).

Your latitude and the aircraft's cruising altitude also make a great difference to the clouds that you may encounter and to your view of them. Short-haul flights generally remain within the troposphere (see page 54), so you may be surrounded by cloud for much of the flight. Such lower-altitude flights often allow interesting photographs of

◄ Two forms of clouds are visible here: growing cumulus congestus near the aircraft and, in the background, well-developed cumulonimbus with anvils (cumulonumbus incus), which have reached the tropopause. The cumulus in the foreground are still growing, indicated by the 'cauliflower-like' appearance, but are beginning to show signs of glaciation at their tops. As freezing progressed, it would not be long before they would be classed as cumulonimbus themselves.

clouds and cloud shadows, of cloud, streets, and of cumulonimbus clouds. On long-haul flights you may fly for some time above the tropopause in the lower stratosphere, when most clouds lie well below you, except, occasionally, some high-altitude cirrus. The cellular structure of many layer clouds, such as altocumulus and stratocumulus, is then often clearly visible. If well-developed cumulonimbus are present when you actually pass through the tropopause, striking photographs of their widespread anvils may often be obtained.

Photography is not particularly difficult, but there are some problems that may occur. When one is looking down obliquely into denser air, there is usually considerable scattering and normal aerial perspective is accentuated, with objects on the ground becoming increasingly blue and indistinct with distance. In addition, at altitude the increased ultraviolet radiation will cause the sky itself to be recorded as a deep, 'unnatural' blue.

A UV filter will help with both of these effects, and it is also worth trying a skylight 1A or 1B filter to block more of the scattered blue light, or adjusting the white balance on a digital camera. A polarizing filter will not necessarily help; the windows of commercial aircraft consist of two or three panes of plastic, which often give broad bands of colour when viewed through a polarizer. Digital images, may, of course, be manipulated later to remove the blue colour cast.

▲ A fine sheet of altocumulus cloud showing the cellular structure. Note the abrupt edge, often seen with this type of cloud, and how the sheet casts a shadow on a lower layer.

▼ Small cumulus clouds and their shadows beneath much higher cirrus and cirrostratus cloud. Although a skylight filter was used, and this was a short-haul flight at reasonably low altitude, the deep blue of the sky is still very prominent.

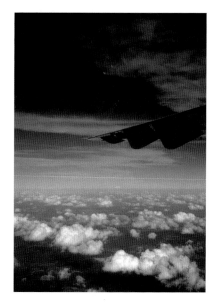

Towards the Sun

If you are lucky enough to secure a window seat during the daytime, the objects that you can photograph (apart from clouds and the ground) will depend on whether you are looking towards the Sun or away from it. The effects visible towards the Sun are: haloes and halo arcs, including parhelia (see page 103); coronae (see page 97); sun pillars and subsuns (see page 104); and sunglint (the reflection of sunlight by lakes or rivers on the ground).

To obtain satisfactory images of halo phenomena, coronae and sun pillars, the Sun itself has to be hidden, which generally means that it must be behind part of the window's surround. Parhelia can usually be photographed by using a telephoto lens to restrict the field of view. Subsuns appear as far below the horizon as the actual Sun is above. They may be quite difficult to see and photograph, because of the limited view through an aircraft window.

◀ This image of sunglint over the sea also illustrates how blue light is scattered by the atmosphere. The sunglint is red, even though the Sun is well above the horizon and is its usual yellow-white colour.

Away from the Sun

Effects that may be photographed away from the Sun are: the aircraft shadow and the 'hot spot'; contrail shadows; glories; rainbows; and the antisolar halo.

Close to the ground or the surface of a cloud, the shadow resembles the aircraft; farther away, the shadow becomes a circular dark spot. At an even greater distance, this changes to a bright spot. This 'hot spot' (as it is known to aerial photographers) lies at the antisolar point and appears to travel across the suface as the aircraft moves. It is usually

most noticeable on the ground when this is covered in grass, crops or trees. It is related to the heiligenschein (see page 105), but arises through a different mechanism. Looking in exactly the same direction as the rays of incident light, every leaf or stalk appears fully illuminated and no shadows are visible. Looking away from that point, shadows come into view.

If your aircraft is creating a contrail, its shadow will often appear on lower clouds. Because condensation trails do not form immediately behind the engines,

there is always a gap between the antisolar point and the tip of the shadow. Sometimes a contrail shadow will be accompanied by a glory (see page 106) centred on the antisolar point, and if the aircraft is close enough to the cloud, it may be seen in the centre of the glory.

The 38° antisolar halo is rare, very weak and hard to see. Rainbows (see page 102) are far more common, and because of the elevated viewpoint, may appear as complete circles. Both are difficult to photograph in their entirety because of their large angular extent.

▶ A subsun, photographed in the early afternoon, when flying through thin cirrostratus, an ice-crystal cloud. The faint secondary image to the upper left is a reflection from the inside of the outer window pane.

weather watching
aurorae and noctilucent clouds

Flights that pass over high latitudes in the Arctic may offer the chance to observe and photograph both aurorae (see page 88) and noctilucent clouds (see page 77). Do not expect great success with either. The major problem here is that both tend to require longer exposures than clouds and other phenomena and, however one may brace onself, it is impossible to hand-hold a camera, keeping it steady, for several seconds. Although noctilucent clouds change relatively slowly, certain types of auroral display change rapidly, which further compounds the problem. Any photographs taken under these circumstances are likely to be of poorer quality than one might like.

kit
stereo images

It is worth remembering that flying in an aircraft offers an ideal opportunity for obtaining a long baseline for stereo photography (see pages 110–13). The main problems here arise from the fact that the camera has to be hand-held, leading to problems with accurate framing. Some degree of misalignment may have to be accepted, but most people find that they can accommodate this when viewing the pictures if the images are printed separately, so that the angle between them may be adjusted to achieve a match. Alignment will be greatly assisted if the horizon or some distinct horizontal line (such as the tops of cumulonimbus anvils) is visible, and a viewfinder grid is used.

Precipitation

Showers, rain, sleet, snow and hail

To meteorologists, 'showers' are individual, isolated cumulonimbus clouds or cumulonimbus clusters that may bring heavy precipitation for a while, as distinct from the more prolonged periods of rain that occur at frontal systems, particularly at warm and occluded fronts (see page 60). A shower may consist of a single cumulonimbus cell (such as that shown on page 72), or multiple cells clustered together. A single cumulonimbus cell will probably die away after about an hour, but multicell clusters may develop into a self-perpetuating system that persists for a long time. They often become organized into a line of cells (known as a squall line) that then becomes self-perpetuating and may travel long distances across country.

Such systems may bring large amounts of rain, hail or (in winter) snow, or turn into major, long-lasting thunderstorms. Even larger are major systems where the circulation within the cloud effectively turns into one giant cell. Such gigantic systems not only have exceptionally strong updraughts and downdraughts, but also feature a giant circulation (known as a mesocyclone) within them. Such supercell storms are extremely violent and long-lasting, and are often the source of major tornadoes.

Any form of precipitation from the clouds tends to appear dark grey when photographed against the light, but show subtle differences when photographed downsun. Rain still appears grey, but snow and hail become white. Shafts of hail are more or less straight, whereas snow, being lighter, tends to show curved trails as it falls from the clouds. On occasions greenish tints are reported to accompany hail, but I have yet to see a photograph that shows any indication of such a coloration.

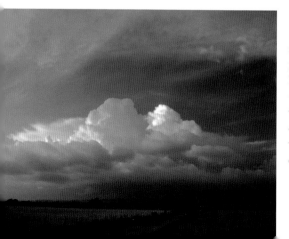

◀ A cluster of cumulonimbus cells, moving away from the photographer. The most distant cell has spread out into an anvil (cumulonimbus incus), and the next two large cells will soon glaciate and do the same. Air streaming into the cluster from the left will soon create more cells.

Devils, waterspouts and tornadoes

There is a whole family of whirls, which raise material from the surface. These range from minor ones (known as devils) to highly destructive tornadoes. Some small devils, such as water devils and snow devils, arise because of a funnelling effect of local topography; slightly stronger ones (dust devils, for example) arise through strong heating of the ground, often combined with varying friction with the surface. These minor whirls are rarely damaging. The stronger waterspouts and corresponding landspouts are caused by strong up- and downdraughts in cumulus congestus or cumulonimbus clouds.

Tornadoes (often known as 'twisters') arise through a different mechanism, which is still not fully understood. They are born within supercell systems and a tornado funnel normally descends from a rotating lowering of the cloudbase (called a 'wall cloud') or from a nearby rain-free area. Wind speeds are extreme, with the highest recorded speed 512kph (320mph). Hurricanes and tropical cyclones also generate large numbers of smaller and less destructive tornadoes. Most major tornadoes occur in the United States, where conditions for their formation are ideal. The majority of 'tornadoes' recorded elsewhere are actually less violent landspouts.

▼ A waterspout, which came ashore near Beachy Head in East Sussex, UK. The hollow core of the funnel cloud or 'tuba' is clearly visible.

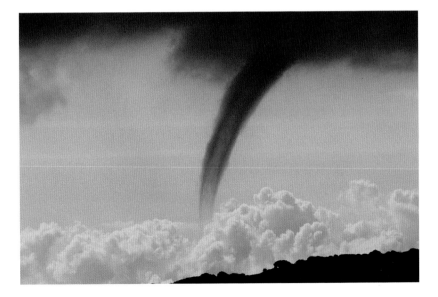

Storm chasing

In recent years a body of individuals has arisen, some professional scientists and photographers, but many amateurs as well, who may be described as 'storm chasers'. They devote a large amount of time to pursuing severe weather. The Great Plains in North America are ideal for this purpose, because they not only have major storms, but also offer a network of roads that may be used. Even so, storm chasers often travel vast distances, yet still fail to catch a storm. Others make for the coast whenever a hurricane is predicted to make landfall. There are many dangers involved in this type of activity, and anyone attempting it needs a considerable amount of meteorological knowledge, both to decide where a suitable storm may occur, and also to remain safe when the storm is 'caught'. If approached from certain directions, for example, torrential rain and violent hail – dangerous in themselves – may completely hide a major tornado. Similarly, with hurricanes, the northeastern quadrant (in the northern hemisphere) has the highest winds and is likely to spawn the most powerful tornadoes.

▼ Typhoon Odessa photographed over the Pacific.

▼ Sometimes tropical cyclones travel in pairs, rotating around one another, when they are known as Fujiwara typhoons. This image from a Space Shuttle shows such a pair: Typhoon Pat on the left, and Typhoon Odessa on the right.

▲ A dramatic tornado descending from the bottom of an imposing cumulonimbus. Debris that is being thrown up from the ground by the high-velocity winds can clearly be seen surrounding and obscuring the bottom of the tuba.

The phenomenon of lightning is an electrical discharge between a cloud and the ground, between two clouds, or between different parts of the same cloud. When the discharge channel of a ground strike is visible, it is commonly known as 'fork lightning', in contrast to 'sheet lightning' if the stroke is invisible, as often happens with the other two types. Because of the dangers they may pose, it is important to know the distance of lightning strokes. The number of seconds between flash and thunder, divided by three gives the approximate distance in kilometres, and by five, in miles.

As mentioned earlier a storm system may consist of several cells, all at different stages of their life. Each cell has a limited period (generally 30–45 minutes). The lightning allows you to track the individual cells. If the bearing of an active cell remains the same, then it is likely to pass overhead. If the storm system is a supercell storm, then the lightning may persist for many hours.

There are several rare forms of lightning and atmospheric electricity:

Ball lightning A luminous, spherical discharge that floats in the air, and is usually a few centimetres across. It may persist for some seconds and change its position. Various colours have been reported, the most frequent being blue.

Bead lightning A lightning discharge that, instead of appearing as an approximately parallel-sided stroke, resembles beads on a string. This form is also known as 'chain lightning' or 'pearl-necklace lightning'.

Rocket lightning A lightning discharge that reaches upwards from the top of a cumulonimbus cloud into clear air, rather than down to the ground or to another cloud.

St Elmo's Fire A luminous discharge from objects on the ground, such as chimneys, the tops of trees and shrubs, wind vanes, or the masts and spars of ships. It occurs when a charged cumulonimbus cloud is overhead, and has even been recorded from a person's hair.

There are only a few indistinct photographs of some of these effects, so any images, however poor, are of great scientific interest. These, or any sightings, should be reported to organizations such as those listed on page 142.

Lightning photography

The most favourable conditions for photographing lightning occur if one has a horizon free from obstructions in the direction of the thunderstorm. A sea horizon is ideal. It is also an advantage if the cloudbase is high, allowing longer lightning strokes to be seen, and at a greater distance. Cloudbase tends to be higher when surface temperatures are high (such as in the tropics or in summer). The situation is complicated, however, by the fact that the frequency

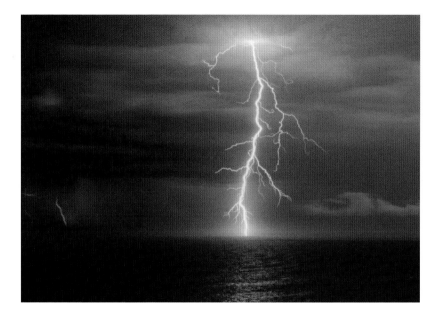

of thunderstorms differs from region to region. Over the British Isles, for example, Scotland has relatively few thunderstorms in summer, because land temperatures are not high. Instead, it has more thunderstorms in winter, when cold air from the northwest sweeps down over relatively warm Atlantic waters, leading to strong convection, and powerful cumulonimbus clouds. In southern England and East Anglia, most storms occur in summer, when land temperatures are highest, and the deepest convective clouds develop. In southern coastal areas, in particular, major supercell storms that have built up over France (or have even originated in Spain) may cross the Channel and bring extremely severe weather, with long-lasting, violent storms, often accompanied by large hail.

Globally, the best locations for shooting thunderstorms are the tropics, where not only is cloudbase generally high, but storms occur most frequently. The Great Plains in the United States are ideal, which is why they are favoured by storm chasers seeking giant thunderstorms and tornadoes. The greatest number of thunderstorms can in fact be found over East Africa, around Kampala in Uganda. Other lightning-prone areas are Florida – part of the state is called 'Lightning Alley' – the northwestern end of the Himalayas, and Colombia.

Taking the photographs

The camera should be mounted on a tripod and set to give a long exposure. The probability of recording a flash is increased if a small aperture is used, especially in combination with a neutral-density filter, to extend the exposure time. The area of the cloud producing the flashes should be watched, and the shutter closed as soon as a lightning stroke is observed. Depending on the time the shutter has been open, the foreground may, or may not, show any detail. Another method, particularly suitable for digital cameras, is to allow the automatic exposure system to control the length of exposure. The intense light from the flash will normally terminate the exposure, but if the stroke occurs in an area not in the frame, the shutter will still close when the rest of the scene has been correctly exposed.

▲ Distant lightning illuminating a cluster of cumulonimbus cells from the inside.

You can increase your chances of obtaining a good picture by monitoring the position and timing of strokes. As mentioned earlier, there may be a single active cell or more than one, and each will be active for a limited time. Once strokes have started, they tend be fairly regular. If you are able to assess the storm's motion it will give you an idea of how the active cells will move and where the camera should be aimed. (Unless the storm is heading towards you, when you should pay attention to your own safety.) If you are controlling exposure manually, the interval between flashes will give you an estimate of when the next stroke will occur.

weather watching
general suggestions for lightning safety

Working outdoors

Avoid any open space where you are likely to be the highest object. Take shelter in a building, under a bridge, or in a car. Do not stand under isolated trees. If on a hill or mountain, move to lower ground if possible. If there is no cover, choose the lowest possible spot, but avoid wet ditches or marshy areas. Do not lie flat, instead crouch down on the balls of your feet, with arms around your legs and your head on your knees. If your hair or that of a companion begins to stand on end, drop to a crouch immediately.

At sea or on a lake you are very vulnerable, so make for shelter as soon as possible. Large yachts generally have lightning protection, but dinghies with metal masts are liable to be struck, so wrap a length of (anchor) chain or wire rope around the wire shrouds and dangle the end in the water, and avoid touching this makeshift lightning conductor.

Working indoors

Stay away from water pipes, wiring, and aerial feeds. Disconnect telephones, modems and vulnerable electrical appliances. If photographing from within a room, avoid coming close to the window or leaning outside. Working from a veranda or porch is generally safe, especially if the house has more than one storey.

Chapter 7
Post-production

With digital images there is, of course, an enormous range of manipulations that may be carried out on the computer. In general, with weather images you will probably not want to carry out the more extreme manipulations such as solarization or posterization, but will normally be concerned with the adjustment of more basic factors, either to remove flaws such as dust spots or to improve the image's accuracy.

Image correction

There are many aspects of image editing, but I have chosen to address only those most relevant to weather photography. It is worth noting that if it is important for you to obtain the best colour and overall the most accurate results, on screen and from your printer, you may wish to invest in a calibration program. There are a number of these, many of which have a small sensor that is placed on the monitor to measure, and correct, the colour emitted, and this is extremely effective.

RAW files

If, when taking the photograph, you suspect that you may want to carry out subsequent changes, it is best to shoot in the RAW format. This will record the image 'as is', with no adjustments. Corrections such as exposure-value compensation and automatic white balance will not be applied. The only real disadvantage of RAW files is that they are larger than even high-quality JPEG files, so fewer may be stored on a memory card. (They are, however, usually smaller than TIFF files.)

Always ensure that you are working on a copy of the file. It is very easy to modify an original file in error. I strongly suggest that you copy any image that you want to edit to a folder, named 'Working files', and manipulate that copy only; then add a suffix to all edited files to prevent confusion.

As mentioned earlier, with the majority of weather subjects the aim is to represent closely the colours that were present in the original subject. This often means overriding (or switching off) any automatic white-balance feature. This is

kit
plug-ins

Most graphics programs will not handle RAW images directly, but make use of 'plug-ins', additional software modules suitable for each camera manufacturer's format. These interpret and manipulate the files before passing them to the main image-editing module. Some of these plug-ins offer extremely sophisticated control of all the basic parameters. If there is no specific plug-in for your particular RAW format, you should be able to use the image-viewing software that came with the camera to save the file in another format (typically TIFF) that can then be imported into the editing program.

an example where it is an advantage to store the images as RAW files. Although it is possible to modify the hue and saturation of images to which an automatic white balance has been applied, it is best to avoid this.

Rather than altering the hue and saturation of an image, it is more often the case that brightness and contrast may need adjustment. It is easy to forget, for example, that you have set an exposure-value adjustment for one particular image, and then find that subsequent images are too dark or too light. Most editing programs offer an automatic function to fix images, usually named 'Autofix', 'Quick Fix' or some similar name. It is always worth trying this function. You may well find that it produces an image that you feel is quite satisfactory.

Equalizing exposure

Occasionally, it may be difficult to obtain optimum exposure for two different areas in an image. Most notably and frequently this applies to sky and foreground, with the latter generally too dark when the exposure is optimized for the clouds or sky. As mentioned earlier, if this is recognized at the time the original photograph is taken, it is a good idea to obtain three images, with

exposures for the sky, the foreground, and at an intermediate exposure. The best of these may then be combined by a photo-editing program.

Frequently, however a simpler method suffices: just adjust the brightness of the shadow area or, if you have made a mistake and exposed for the foreground rather than the sky, adjust the latter's brightness (i.e., the highlight area). It may also help to alter the contrast slightly in one or the other area. Again, the editing program's 'quick fix' options may be perfectly adequate for this.

▼ The left-hand image (taken to show the use of a polarizer to accentuate a reflection) was exposed for the sky, resulting in the surrounding area being much too dark. (Even the sky is slightly too dark.) By selecting the shadow area, its brightness was increased in the right-hand image, improving both sky and foreground.

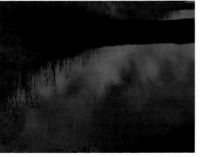
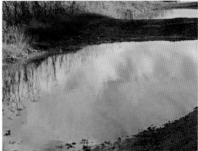

▼ The image immediately below is an untouched scan from a transparency. Apart from the numerous dust spots, the angle of the horizon also requires correction. The bottom image is the final, corrected version, which covers a very slightly smaller frame, because the inclination of the horizon has been corrected, so the image had to be cropped.

All photo-editing programs include methods for removing dust spots and scratches. In general, the automatic routines (as with those on scanners) are sometimes successful, but usually some manual correction is required. This is usually fairly easy in Photoshop, for example, using the 'clone stamp' and 'healing brush' tools. The removal of scratches is sometimes tedious, but is usually successful. I have found it best, when using the clone tool, to sample at frequent intervals, alternating between the two sides of the scratch. With large areas of even tint, a large tool radius may be used, but in complex areas it is often necessary to reduce the pixel size of the tool to 10 or less.

Cropping

It is all too easy to forget that many photographs may be improved by judicious cropping. There is a natural tendency to accept the image format determined by the camera. The introduction of digital sensors has meant that the long-established standard set by the 35mm frame has begun to change, especially with the introduction of the four-thirds format sensors in certain cameras. Quite apart from the removal of distracting material, close cropping can dramatically increase the impact of certain images.

▼ The top image shows the full frame. The crop underneath it has concentrated attention on the main subject. As well as deleting the distracting cloud in the upper left, it has reduced the prominence of the area in the upper right corner that has been darkened by the polarizing filter.

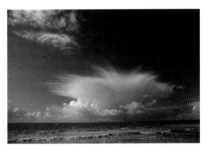

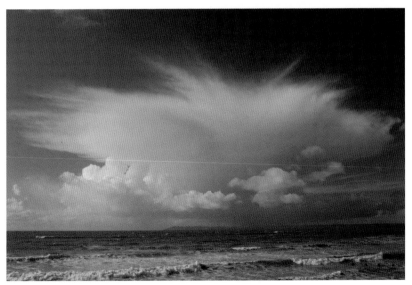

Panoramic images

As mentioned earlier on pages 114–15, considerable care is required to achieve acceptable results with panoramas of weather subjects. It is often far more difficult to obtain satisfactory matching with images that require a smooth transition between large areas of even tint, than when combining images that contain a lot of detail (such as townscapes, for example). Manual intervention is frequently required in adjusting alignment, and small corrections to brightness are sometimes required. However, even apparently suitable subjects may sometimes prove difficult to combine, the most frequent problem being that of unrecognized, rapid motion of clouds.

It is sometimes extremely difficult and time-consuming to correct errors made in exposure. If more than one computer program is available, it is certainly worth trying each of them with the same set of images. Occasionally, the simpler and less sophisticated programs produce the best results.

▼ Three separate stitching programs all had difficulty constructing this panorama, and none achieved an even transition from one frame to the next. This is undoubtedly because the exposure was not locked. All had problems incorporating the final (right-hand) frame. This is the best of the results (achieved with Olympus Camedia Master Pro), and even here, after adjustment of the brightness and colour saturation of the last image, considerable further correction to all the individual images was required.

Sometimes the very nature of the subject and the prevailing conditions may make matching across the frames very difficult. Although it may not be readily apparent to the eye, the illumination of the sky and clouds may change quite rapidly at sunrise or sunset, in particular, so that even locking the exposure may still result in images with slightly different illumination and slight changes in colour saturation. Some computer manipulation of the images may still be necessary. Although panoramic programs are capable of combining several individual images as a single step, better results may sometimes be obtained by combining images sequentially in several steps: A + B; AB + C; ABC + D; and so on. This usually involves converting all the individual files into the TIFF format before attempting any stitching, otherwise there will be a size mismatch between the combined and individual images.

▼ Here the Olympus Camedia Master Pro program has achieved excellent matching of tints and outlines. (The large black object on the horizon is a container ship.)

Although weather phenomena, especially optical effects, are generally best photographed in colour, monochrome images are sometimes more effective aesthetically. Although nearly all photo-editing programs offer a 'greyscale' function, which will convert colour images into monochrome in a single step, you have better control over the process if you choose a function that accesses the colour channels individually. In Photoshop, for example, the 'Enhance > Adjust Color > Adjust Hue/Saturation' function provides access to seven channels, one of which is the Master, controlling all channels together. However, by setting the saturation of each of the other six channels (reds, yellows, greens, cyans, blues, magentas) to −100, the image is converted to monochrome. The brightness of each individual channel may be varied independently. Alternatively, the brightness and contrast of the image may be modified by the various options under 'Enhance > Adjust Lighting'.

There are, however, many methods that can be easily found via the internet and put to good use, creating a variety of effects.

◀ An example of a conversion to monochrome. The six channels of the top image were desaturated, and the resulting image altered slightly by varying the brightness of the highlight and shadow areas.

Glossary

Accessory clouds Forms that occur in association with one or more specific cloud types.

Alexander's Dark Band A dark area of sky between a primary and secondary rainbow.

Altocumulus A cloud of medium height, consisting of individual clumps separated by lanes of clear air.

Altostratus A layer cloud of medium height and of grey or blue-grey appearance.

Anticyclones A centre of high pressure from which air flows out to surrounding areas.

Antisolar point The point exactly opposite the Sun relative to the observer's head.

Aurorae Vibrant colours in the polar skies caused by the collision of charged particles with the atmosphere.

Billows Rolls of cloud, separated by narrow gaps, arising from wind shear operating on a layer of cloud.

Cells Individual convective units of cloud that often form together to create larger cloud structures.

Circumhorizontal arc A coloured arc that is parallel to the horizon.

Circumzenithal arc A coloured arc that is centred on the zenith.

Cirrocumulus A high ice-crystal cloud consisting of tiny, thin clumps of cloud.

Cirrostratus A high and generally very thin ice-crystal cloud.

Cirrus A wispy, high ice-crystal cloud.

Cloud streets The effect when a series of cumulus clouds are arranged in long lines stretching downwind, rather than being randomly scattered. These are also known as cumulus radiatus because they appear to converge through perspective.

Colour temperature The description of the colour of a light source by comparing it with the colour of light emitted by a theoretical perfect radiator at a particular temperature expressed in Kelvin (K). Note that 'cool' colours such as blue, have high colour temperatures and 'warm' colours such as red, have low colour temperatures.

Contrails Trails of condensation that are left when an aircraft's engines inject a significant amount of water vapour into the atmosphere.

Coronae A series of coloured rings that appear around the Sun or Moon when their light shines through a thin layer of cloud.

Crepuscular rays Bands of shadow or rays of light that appear to radiate from the position of the Sun, whether this is high in the sky or low (even below) the horizon.

Cumulonimbus A type of cloud that develops from cumulus clouds and may have a huge vertical extent, and produces rain, hail, snow or lightning.

Cumulus Low-level individual, heaped clouds that do not give rise to rain.

Depressions Areas of low pressure into which air flows from surrounding areas.

Distrails Dissipation trails that occur when an aircraft flies through a thin layer of cloud, leaving a clear path behind it.

Fallstreak holes Holes that appear in certain clouds as a result of either an aircraft leaving a distrail or a rapid chain reaction of freezing particles that fall out of the cloud.

Fogbows A similar effect to rainbows, albeit one that only occurs when the water droplets involved are very small. These are generally white.

Glories A series of one or more coloured rings around the antisolar point.

Haloes Circular optical phenomena produced when sunlight is reflected or refracted by ice crystals in the atmosphere.

High-altitude dust Particles projected into the upper atmosphere by a volcanic eruption, producing orange or red tints.

Incus The term for the anvil shape at the top of cumulonimbus clouds that have spread out at the tropopause or other inversion.

Inversion A layer where temperature increases with height, contrary to the normal decline with altitude.

Iridescence Narrow bands of colour that occur at the edges of thin clouds.

ITCZ The Intertropical Convergence Zone; an area of low pressure and prominent clouds that circles the Earth near the equator.

Jet streams Long, but narrow, fast-flowing air currents, usually at breaks in the tropopause and at boundaries of air masses of different temperatures.

Kelvin-Heimholtz waves Short-lived billows that appear similar to breaking waves, caused by large wind shear.

Mesopause The boundary between the mesosphere and the thermosphere.

Lenticular clouds Altocumulus, and stratocumulus or cirrocumulus clouds of a smooth, lens-like appearance.

Lightning An electrical discharge, normally between a cloud and the ground or within a cloud.

Mesosphere The third layer of the atmosphere.

Nacreous clouds A high cloud type in the lower stratosphere.

Nimbostratus A relatively featureless cloud of medium height and often a dark grey appearance.

Noctilucent clouds The highest clouds in the sky, located in the mesosphere.

Parhelic circle A white arc, at the altitude of the Sun, that is parallel to the horizon.

Parhelion Also known as a mock Sun or sundog; a bright spot on or just outside a 22° halo.

Polar fronts The boundaries where polar air meets tropical air.

Precipitation A number of effects such as rain, drizzle, snow and hail that falls to the ground.

Purple light A very rare purple glow in the twilight arch that arises as the result of volcanic activity.

Rainbows Phenomena that arise when sunlight is reflected back towards an observer from raindrops, and displaying the colours of the spectrum.

Shadow of the Earth A steel-grey band that rises in the east as the Sun sets in the west.

Stratocumulus A low cloud featuring sheets of separate cloud masses in rounded heaps.

Stratosphere The second layer of the atmosphere, between the troposphere, below, and the mesosphere, above.

Stratus A low cloud that is relatively featureless, but does not produce significant precipitation.

Subsun A halo phenomenon that forms a white ellipse below the horizon.

Sun pillar A vertical pillar of light through the position of the Sun.

Tropopause The boundary between the troposphere and the stratosphere.

Troposphere The lowest layer of the Earth's atmosphere.

Twilight arch The semicircular area above the rising or setting Sun.

Wave clouds Clouds that are smooth in appearance and are created when air is forced to rise over an obstacle.

Whirls A range of effects including dust, snow and water devils rising in severity to tornadoes.

Wind shear A difference in the wind speed or direction over a short distance.

Virga Trails of precipitation that fall from clouds, but fail to reach the ground.

Further reading

Books

Dunlop, S., *Dictionary of Weather*, Oxford University Press, Oxford, 2001

Dunlop, S., *How to Identify Weather*, HarperCollins, London, 2002

Greenler, R., *Rainbows, Haloes, and Glories*, Cambridge University Press, Cambridge, 1980

Können, G.P., *Polarized Light in Nature*, Cambridge University Press, Cambridge, 1985

Lynch, D.K. & Livingstone, W., *Color and Light in Nature*, 2nd edn, Cambridge University Press, Cambridge, 2001

Meinel, A. & M., *Sunsets, twilights, and evening skies*, Cambridge University Press, Cambridge, 1983

Meteorological Office, *Cloud Types for Observers*, Stationery Office, London, 1982

Minnaert, M., *Light and Colour in the Open Air*, G. Bell, London, 1940; Dover, New York, 1984

Minnaert, M., *Light and Color in the Outdoors*, Springer-Verlag, New York, 1993 (revised edition of previous item)

Scorer, R., *Clouds of the World*, David & Charles, Newton Abbott, 1972

Internet resources

Amateur satellite-image reception information:
www.geo-web.org.uk

Forecast charts:
www.meto.gov.uk/weather/charts/index.html

General weather resource:
www.met.rdg.ac.uk/~brugge/

Hurricane information:
www.nhc.noaa.gov

Royal Photographic Society:
www.rps.org

Satellite images (geostationary):
www.eumetsat.de

Satellite images (polar-orbiting):
www.sat.dundee.ac.uk

Synoptic charts (actual observations):
www.metoffice.gov.uk/education/data/stationplot.html

UK weather:
www.meto.gov.uk

US weather:
www.nws.noaa.gov

World-wide weather:
www.worldweather.org

Index